NOTE ABOUT THIS SERIES

TO GET HOLD OF THE INVISIBLE, ONE MUST PENETRATE AS DEEPLY AS POSSIBLE INTO THE VISIBLE. THIS IS THE ESSENCE OF PAINTING. § THE ARTIST MUST FIND SOMETHING TO PAINT. PAVEL TCHELITCHEW SAID, "PROBLEMS OF SUBJECT-MATTER HAVE BEEN LIKE OBSESSIONS — IMAGES HAVE HAUNTED ME SOMETIMES FOR YEARS BEFORE I WAS AT LAST ABLE TO UNDERSTAND WHAT THEY REALLY MEANT TO ME OR COULD BE MADE TO MEAN TO OTHERS." THESE ESSENTIAL IMAGES AND THEMES IN A BODY OF WORK — PEOPLE, PLACES, THINGS — ARE EQUIVALENTS OF THE ARTIST'S INNER, INVISIBLE REALITY. § THE ARTBOOKS IN THIS SERIES EXPLORE SPECIFIC SUBJECTS THAT HAVE MOVED CERTAIN ARTISTS AND STIRRED OUR DEEPEST RESPONSES.

Charles Burchfield, New York City, 1941, Photograph © Arnold Newman

A CHAMELEON BOOK

CHARLES BURCHFIELD'S SEASONS

Guy Davenport

POMEGRANATE ARTBOOKS, SAN FRANCISCO, CALIFORNIA

A CHAMELEON BOOK

Complete © 1994 Chameleon Books, Inc.
Text © 1994 Guy Davenport

Published by Pomegranate Artbooks
Box 6099, Rohnert Park, California 94927

Produced by Chameleon Books, Inc.
211 West 20th Street, New York, New York 10011

Creative director: Arnold Skolnick
Designer: Arnold Skolnick
Editorial assistant: Lynn Schumann
Managing editor: Carl Sesar
Composition: Larry Lorber, Ultracomp
Printer: Oceanic Graphic Printing, Hong Kong

Library of Congress Cataloging-in-Publication Data

Davenport, Guy
 Charles Burchfield's seasons / Guy Davenport.
 p. cm. — (Essential paintings series)
 "A Chameleon book."
 ISBN 1-56640-979-9
 1. Burchfield, Charles Ephraim, 1893-1967 — Criticism and
interpretation. 2. Seasons in art. I. Burchfield, Charles Ephraim,
1893-1967. II. Title. III. Series.
ND1839.B8D38 1994
759.13 — dc20 93-46654
 CIP

Acknowledgments

I cannot thank Guy Davenport enough for his wonderful essay on this most inspired artist. Nor can I ever fully express my gratitude to Nancy Weekly, curator of the Burchfield Art Center, for her constant interest and support, both in lending us transparencies and helping us find many of the images in this book.

I thank all the museums who supplied the superb images; many of them had to create original photography for this book. Special thanks to Munson Williams Proctor Institute; Mead Art Museum; the Whitney Museum of American Art; New Britain Museum of American Art; Pennsylvania Academy of the Fine Arts; The Ogunquit Museum of American Art; and the Salem Public Library.

Thanks also to Lillian Brenwasser from the Kennedy Galleries; Sid Deutsch Gallery; Art Resource, who opened up their Burchfield files; and all the private collectors who shared their works.

The collaboration among my staff at Chameleon has made this project possible. Many thanks go to Carl Sesar; who did the editing; Jamie Thaman, who read the proofs; Larry Lorber, who set the type; Nancy Crompton, who did the paste-up; and Lynn Schumann, my assistant, who coordinated all aspects of production. Thanks also to Joanne Gillett and Halina Rothstein for their continued support.

I want to thank my wife, Cynthia Meyer, whose creative presence is felt in my work.

Arnold Skolnick

N 1939, when Poland and Czechoslovakia fell to Hitler's armies and Finland to Stalin's, the United States was recovering from the Great Depression that had begun ten years before. There was an upsurge of prosperity in industry and a renaissance in the arts. In this year the publishing firm of Simon & Schuster published a large, handsome book, *A Treasury of Art Masterpieces from the Renaissance to the Present Day,* by Thomas Craven. Its one hundred color plates, engraved and printed by the Condé Nast Corporation, are still unexcelled, half a century later, in brilliance and fidelity. This expensive volume (it cost ten dollars) might have been the beginning of an American culture the tone and depth of which we can only guess, as within a year it was obliterated by World War II, over whose duration our books became shoddy, and our attention to the arts was wrenched out of a hopeful course.

The surprise of this ground-breaking book is that Thomas Craven boldly chose for its last six paintings John Sloan's *McSorley's Bar*, Charles Burchfield's *November Evening*, Thomas Hart Benton's *Persephone*, John Steuart Curry's *The Line Storm*, Reginald Marsh's *Wooden Horses*, and Grant Wood's *Woman with Plants*.

"What time will do with these vigorous Americans," Craven wrote in his introduction, "I am not prepared to say, but they fulfill at least one of the preliminaries to great art: they are part of the society in which they live; their paintings reflect the color and character of that society; and their canvases, exhibited in European galleries, stand out as conspicuously American productions. They are the leaders of the most exciting and important art movement existing in a troubled world...." Craven concluded his defense of his inclusion of contemporary American painting by flattering "the modern

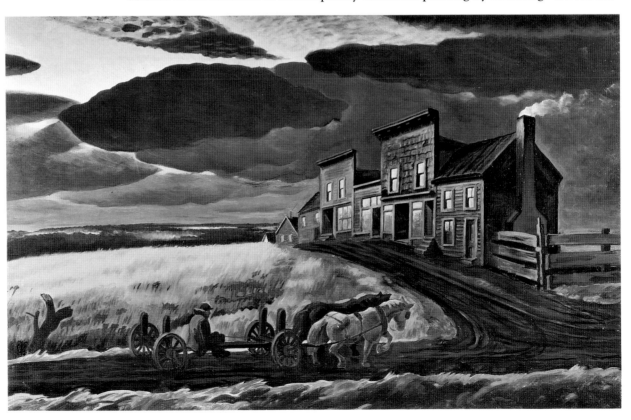

NOVEMBER EVENING, 1934
Oil on canvas, 32⅛ x 52 inches
The Metropolitan Museum of Art
George A. Hearn Fund, 1934

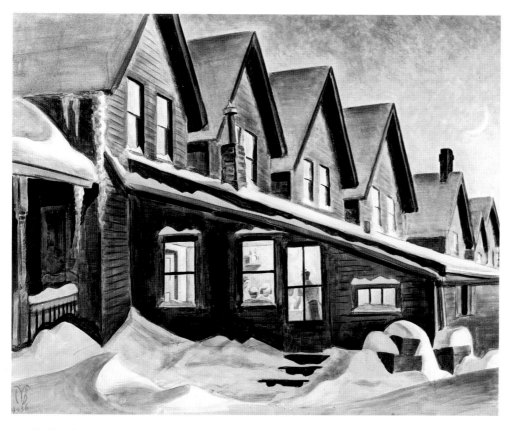

SIX O'CLOCK, 1936
Watercolor, 24 x 30 inches
Everson Museum of Art, Syracuse, NY
Museum Purchase with funds from the Jennie Dickson Bucj Fund

reader" who, "after reviewing the masterpieces of the past, seeks naturally the most significant works of his own time."

When the European museums opened their doors seven tragic years later, the American paintings shown in them would be by Rothko, Gorky, Pollock, and Motherwell.

I

Charles Burchfield in 1939 was 46, living in Gardenville, New York, a suburb of Buffalo, painting, listening to Sibelius, and pondering the existence of God. Except for six months (1918–1919) at Camp Jackson, South Carolina, and a brief stint (one day) at the Academy of Design in New York City, his life was lived along the southern shore of Lake Erie. Born in Ashtabula Harbor, Ohio, he was raised in Salem, some sixty miles deeper into the state. His professional work as a wallpaper designer was in Cleveland and Buffalo. He exhibited no trace whatever of the bohemian propensities we associate with artists. He was happily married, with five children. After refusing for most of his adult life to believe in any religious creed—"the only divine reality is the unspeakable beauty of the world as it is," he wrote in his journal on July 26, 1936—he became a Lutheran in 1944, to obliterate the only difference between him and his wife. He was a stubborn, honest realist; the conversion was not without anguish

and awful doubt, as he recorded over many years in his journal (which he kept from 1911 until his death in 1967), and when it came, it was an act of love.

The year after Craven's *A Treasury of Art Masterpieces*, Peyton Boswell, Jr., published *Modern American Painting* (Dodd, Mead & Co., 1940), another large, well-printed book in which Burchfield figured, this time with two color plates. The plates used for this book were engraved for *Life*, which had made its readers familiar with Grant Wood and John Steuart Curry as well as many other painters whose careers were considerably advanced by so popular a magazine.

Boswell's opening sentence was a prophecy which, I would like to think, was not wrong but delayed: "America today is developing a School of Painting which promises to be the most important movement in the world of art since the days of the Italian Renaissance." There's the merest touch of Babbittry in this sentence, some foggy crystal-ball gazing, and a large amount of truth buried under the immense success of Abstract Expressionism. Today Benton's mannerism retains a slippery interest because of its folklorish subject matter; Peter Blume is all but forgotten, undeservedly; Cadmus is emerging after years of neglect; Curry holds his own in good museums; Hopper has become an American classic; Reginald Marsh and Georgia O'Keeffe have solid reputations; Charles Sheeler stands firm; Grant Wood—the Charles Ives of American painting—exists in a scandal of misinterpretation.

Burchfield's paintings in these two crucial books are *November Evening* (1931–1934) in Craven and *Over the Dam* (1936) and *Six O'Clock* (1936) in Boswell; all three are winter dusks. All three would be studies of gloomy weather except that in *Six O'Clock* we can see a warm, bright kitchen and a family at table. Although Burchfield would become a scientifically exact student of foul weather—of rain, storms, and slush—it was his summer paintings that moved him to his most lyric experiments.

Quite early in the century Burchfield began to paint landscapes in an original Expressionist manner, apparently without influence. He belonged to no school, had no master, did not derive from any other painter. We can point to Van Gogh's whorls of light around stars and to his writhing trees. We can remember Samuel Palmer and Blake. But none of these influences can be traced. In many paintings Burchfield used cartoon-strip squiggles (*agitrons,* cartoonists call them) to indicate movement or vibrancy. From the cartoonist's vocabulary he also took *squeans* and *blurgits* to indicate shafts of sunlight and the sounds of crickets.

That one medium can be an analogue of another in the arts is a characteristic of Modernism. Whistler had his symphonies, arrangements, and nocturnes; Pound his cantos; Eliot his quartets. Debussy's *La Mer* is a seascape. It has always been understood that Sibelius's music evokes the forests and plains of Finland (not, as some have said, mountains: Finland is as flat as a pancake). In Sibelius Burchfield found a kindred spirit, a guide to transposing nature into an ecstatic exaggeration of itself, and perhaps his belief in God. Debussy, whom he disliked, was an atheist; if Sibelius was an infinitely greater composer, and a believer, there was an argument for faith in the contrast.

Clover Field in June (1947), for instance, is clearly meant to be visual music. The foreground is whimsically from a bee's-eye point of view, with the perspective naively

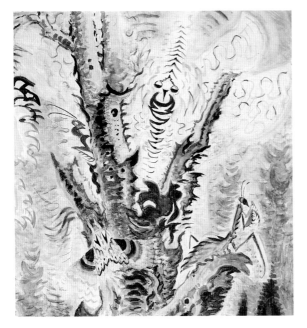

GATEWAY TO SEPTEMBER (detail), 1946–56
Watercolor on paper, 42½ x 56 inches
Hunter Museum of Art, Chattanooga, TN
Gift of the Benwood Foundation

making the clover unnaturally large. The solitary tree—a Burchfield signature—is outlined in light, as are the clouds. Shafts of light stream down the sky. The design hovers between naturalistic and abstract. Although Grant Wood could not have seen this painting, ones like it gave him the idea for the outsized leaves on the trees in *The Birthplace of Herbert Hoover*, where they announce the tongue-in-cheek wit of that quiet little satire. Exaggeration is native to comedy, and comedy in Burchfield is a dimension of joy. The enormous dragonflies, with their comic-strip agitrons, appear in paintings of extraordinary lushness in color and light.

Visionary is a word that recurs in writing about Burchfield. Its use is problematic in that the visionary heightening characteristic of his ecstatic landscapes is always grounded in the real. Anyone who has visited the terrain around Argenteuil and Giverny has wondered how so bland and ordinary a countryside can be so magically beautiful in a canvas by Monet. Impressionism in the hands of Pissarro, Van Gogh, and Seurat kept moving toward the visionary and the abstract. The step from Van Gogh to Willem de Kooning is a short one, but one that Burchfield never took. Or took, rather, in his own way, into an idiomatic calligraphy of his own devising, a sign language for radiant light, for wind, for insect song, for emanations. "To see nature with the eye of an interpreter," he wrote toward the end of his life in his journal (June 30, 1964).

Interpreting—reading—nature is an enterprise that came over on the *Mayflower*. To the Puritan mind nature was God's other book. The pioneer botanists of northern Europe were largely Protestant, with an understanding that the medicinal properties of plants were a gift from God to be discovered and that the beauty of plants was a fitting substitution for Catholic statuary and ornament in churches and burial grounds. The flower garden joined the kitchen garden of the humblest homes.

American writing from its beginning has always been concerned with the forest, the clearing, the farm, the orchard. The honey bee came over with the settlers of New England, along with the apple tree and the pear. Two enormous ecologies blended in the New World, where pumpkin, maize, persimmon, melon, and other native vegetables changed the European palate. But it was the endless forests, and the prairies beyond the Mississippi, that caught the imagination of travelers and pioneers. In Parkman's great history of the British and French in America there is a subtext of descriptions of nature (Parkman prided himself on having visited all the sites, from the swamps of Florida to the Canadian woods in winter, as well as the Oregon Trail). These descriptions, as graphic as any of Thoreau's, become a metaphor for the awful struggles between settlers and the wilderness, with the Native Americans, and with the intractable hardships of weather, distance, and the imposition of housing and cultivation of the land.

Burchfield's paintings can be categorized as images of industry (parallel to Charles Sheeler and Demuth—Marianne Doezema's *American Realism and the Industrial Age*, published by the Cleveland Museum of Art, 1980, is an excellent overview); the domestic (city streets, homes, interiors); and woods, forests, and fields. There are a few portraits, a few still lifes.

Like the young Wordsworth and Thoreau, Burchfield's love of nature began in

LOCUST TREE IN AUTUMN, 1963
Watercolor on board, 48¾ x 31¾ inches
New Britain Museum of American Art, New Britain, CT
Gift of Olga Knoepke

Mar. 16 - 1926

Neither the past nor the future is of any account. *Now* is the moment — the supreme instant of my life Now, living in gardenville and going back + forth to work on the bus — now is the time to live, to do my best work — these people are the most interesting people on earth — the people I ride with — here + now is my appointed time to work — away with hesitancies, longings for what used to be in Ohio, and what might be in the future, away with "defeatist attitudes — *now* must *work* be done, no matter what the difficulties + hindrances —

Autograph manuscript page, October 9, 1926; Journal XXXVII, p. 9
Charles E. Burchfield Foundation, on loan to the
Burchfield Art Center, Buffalo, NY

childhood. His journals, with which he takes his place among American writers, record fifty-six years of excursions and meditations. The journals that have survived number ten thousand pages. J. Benjamin Townsend's selections, arranged thematically, run to seven hundred pages, and are aptly subtitled *The Poetry of Place*.

A culture is always a complex of cooperative and opposing forces. No work of art is wholly intelligible out of its context. A culture is a dialogue among its components. When we are privileged to know the elements of the dialogue, we can see better into the aesthetic of a particular artist. One of the liveliest activities of a culture is to concern itself, over many years and in the sensibilities of many artists, with a subject which thereby undergoes a series of transformations. Consider Emily Dickinson's "Four Trees" (1863) and Burchfield's *The Three Trees* (1931 – 1946):

Four trees upon a solitary acre
Without design
Or order, or apparent action,
Maintain.

The sun upon a morning meets them,
The wind.
No nearer neighbor have they
But God.

The acre gives them place,
They him attention of passerby,
Of shadow, or of squirrel, haply,
Or boy.

What deed is theirs unto the general nature,
What plan
They severally retard or further,
Unknown.

Thoreau attempted to answer the question implicit in the last stanza in his *Faith in a Seed* (deciphered and published in 1993). Emily Dickinson knew what "deed is theirs"—to sustain life on this planet by inhaling carbon dioxide and exhaling oxygen—but she was not the kind of poet who would allow that to be a comprehensive explanation of trees. It is the raw fact of the trees' existence that Dickinson focuses on, making a piercing riddle of that fact. Nothing has a neighbor nearer than God (and Burchfield puts a church in the far background to rhyme with Dickinson's poem, and also has a fourth tree in the middle distance). She makes the meadow masculine ("Him") and constructs a geometry of attention: of passerby, squirrel (who will have planted the trees, most likely, according to Thoreau), shadow, and boy. Shadow? The trees have their shape from the arrangement of branches and leaves that best, for that particular tree, receives maximum light. So the sun gave them their shape. In Burchfield's painting we can see how the rightmost tree has the space (that is, the available light) to bend to the left into the openness allowed by the high branches of the middle tree.

Dickinson's boy is also, like the squirrel, a disseminator of seeds, being a climber for nuts and fruit. (Burchfield in his journal records many encounters with bright-eyed, freckle-faced boys in whose company he delighted, and whom he liked to have watch him sketch, in contrast to nosey people and hunters who asked stupid questions.)

The metaphysical statement of the poem is one we can find in a different eloquence in Rilke and in the painter Odilon Redon. Burchfield's painting is more a hymn than a questioning. These trees *are*. Their arrangement makes a pun on his monogram

signature so that an *I am* is cryptically encoded in the *they are* of the trees. (Goya put his own profile along the underside of the long limb on which mysterious people are perched in the etching "Ridiculous Folly" of the *Disparates* suite.) Burchfield's trees are beings, presences, silent and majestic cohabitants of the earth with the lion and the robin. They are alive in a different way, secretly in public view. He has painted them under their nourishing clouds, in a fertile meadow, just outside a town.

It is evident that he has painted them in reverence and awe. His sense of nature's sacredness, a kind of worship that never confused creation and Creator, was enforced by a lifelong study of kindred spirits. He found them in Händel and Sibelius, in descriptions of nature in American and Scandinavian literature, even in Walt Disney (with severely qualified success). He was particularly admiring of two prose poems by Maurice de Guérin (1810 – 1839) that were discovered and published by George Sand, "Le Centaure" and "Les Bacchantes." The one is spoken by an aging centaur who, like the bacchantes of the other, is an initiate into the vibrantly mystical processes of nature and whose experience of forests, mountains, and the seasons is ecstatic. These longish poems, whatever their influence on Mallarmé's fauns and nymphs, sound lugubrious and rhetorical to modern ears. Burchfield read them in his own way, as Blake read the unreadable Ossian, finding his own pantheistic spirit in them. But then he could find that spirit as well in the American novelist Zona Gale. Genius has its own way with friendships.

33 Burchfield's trees range in style from the realistic to the visionary. The *Golden Dream (1959)* is of an imaginary tree on which monarch butterflies hang, like blossoms. It is outlined by a golden aura, and stands in rippling water. His style had evolved by this time into a calligraphy of such sureness and versatility that every brush stroke had its distinct accent.

Trees stand in weather. The names of the months and seasons recur in Burchfield's
8 titles, along with times of day. Thus we have titles like *Rainy Night* (1929 – 1930) (which is of buildings, streetcar tracks, automobiles, a water tower), *Winter Bouquet*
14 (1933), *The Coming of Spring* (1917 – 1943), *Iron Bridge and Winter Sun* (1940 – 1943). Burchfield progressed over the years from the prose of realism to the poetry of color and tone, and on into a music of natural phenomena. Nature is never still, never quiet, never lit by the sun with a sameness that lasts a second.

Heraclitus might also have said that we can't see the same tree from one minute

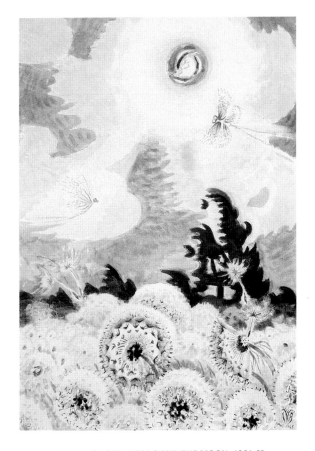

DANDELION SEED HEADS AND THE MOON, 1961-65
Watercolor on paper, 54¼ x 38½ inches
Collection of Irwin Goldstein, M.D.

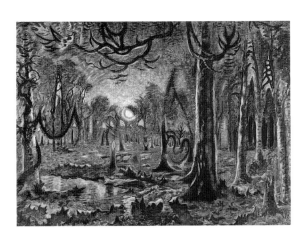

MOONLIGHT IN NOVEMBER WOODS, 1947–62
Watercolor on paper, 38¼ x 53½ inches
Private collection

to the next. Burchfield spent his life in a climate in which the seasons change in slow transitions, with long autumns and springs, with very hot summers and very cold winters. Violent winds blow off Lake Erie. The land is fertile, and figured in the American and European imagination as an earthly paradise. Wordsworth and Coleridge once planned to found a utopian society along the Susquehanna. Charles Fourier dreamed of an ideal society in Ohio, and Napoleon after Waterloo hoped that he could get there and set up as a gentleman farmer.

Burchfield accepted Ohio and western New York as his world. It proved to be inexhaustible, like Thoreau's few square miles around Concord. The idea of the artist and writer as a regionalist was a dominant one. Willa Cather and Sinclair Lewis were daringly modern in their locales, as were Grant Wood and John Steuart Curry. William Carlos Williams is a poetic counterpart to Burchfield in his choice of a New Jersey industrial town for his *place.* He is also like him in his poems about flowers, backyards, and trees. In Burchfield and Williams we also find a groundwork—an existentialist perception—in the encompassing idea that whereas all man-made things are subject to entropy, nature is not. Nature is self-renewing and perennial.

Houses in Burchfield are usually dilapidated, their vulnerability to weather and time emphasized. In *End of the Day* (1938) a row of houses is painted in downhill **10** perspective. They are in a harsh midwinter, sagging and buckling. The stand of bare trees behind the houses will bud out in spring. Even his industrial scenes, painted for *Fortune* magazine, do not glorify technical progress so much as depict iron monsters intruding. *Railroad in September* (1952) shows a small section of rails and crossties along which autumn wildflowers and hardy weeds are perkily growing.

A thorough study of Burchfield will have the record of the journal as a resource for iconography and the artist's theorizing. One must tread warily here: words are not paintings. Two orders of the imagination seem to lie parallel until we realize that Burchfield the writer is different from Burchfield the painter. They crisscross each other in ways that demonstrate the complex unity of this imagination. In 1916—in the first period of his visionary watercolors—he painted *Ghost Plants (Corn and Sunflowers)* **3** (1916). Twenty-six years later, in 1942, he recorded a dream about a garden in which all the flowers were white ("huge sunflowers, the leaves and stalks pale gray green... gigantic white carnations...white gladiolas"). And in the dream was Shakespeare, who told Burchfield that these last were Crescent Moon gladiolas, "his special pride" (implying that Shakespeare was the gardener). The crescent moon itself was in this sweet dream, from which Burchfield awoke "with the smell of mignonette in [his] nostrils." Shakespeare does not mention Crescent Moon gladiolas; they do not exist.

He could also dream about Edward Hopper and tame blue grosbeaks and nonexistent books with paintings by children. In his dreams Sibelius wrote him letters which, despite their being in Finnish, he could read. And he dreamed of Sibelius's "mysterious North."

"If only," Picasso once said to a critic, "you could see the paintings in my mind!" We do not need this evidence of the artist's interior world; even those of us who are not artists have it. But in the case of artists who move in the world as level-headed and practical businessmen (Wallace Stevens and Charles Ives, insurance executives; William

Carlos Williams, pediatrician), the discrepancy between the daily round and intense creativity is suspiciously instructive. The imagination seems to thrive on stolen time. Some of Burchfield's most brilliant paintings were done in after-hours and on weekends. Henri Rousseau began as a Sunday painter.

II

On a January night in 1943 Burchfield went in his journal:

To me, the artist, interested chiefly in weather—all weather is beautiful, and full of powerful emotion—this "icy blast" from the vast northeastern wastes— the monotone of gray and black and white—Trees seem to have grown thinner, taller, and shrink into themselves, as do houses and other objects—That I did not realize this shows that I have allowed myself to grow dull and insensitive thru the disuse of my faculties—my ability to enjoy whatever is going on in the world of nature...

He went on to speculate "whether I am drifting into the oblivion of the mediocre outlook—that outlook which the masses hold, and which is worthless—deadening."

Far from drifting into mediocrity, Burchfield in these years was rediscovering the eccentric vitality of his first work, the never-quite-abstract configuration of nature. There *was* a drift, and how conscious he was of it we will never know. He was returning to a *topos* deep in tradition: the four seasons. The Renaissance had thought of this theme as the dance of the Horae (the seasons) to the music of Apollo. Or, as in Poussin's painting, the dance of the Hours to the music of time. At the dawn of Greek antiquity there was thought to be three seasons, with winter as a dead gap between autumn and spring. Alkman in the 6th century B.C. wrote a little poem suggesting that winter, for all its bleakness and starvation, ought to be a season, too.

Neoclassicism more than classicism itself saw great significance and beauty in the cyclical recurrence of four seasons. From Botticelli's *Primavera* to the present, this set of four stages in a metamorphosis—a kind of quartet for the visual arts—has attracted artists, poets, and composers. Without rehearsing the whole tradition, we can instantly think of James Thomson's *The Seasons* (1730), which Haydn recreated in his oratorio *Die Jahreszeiten* (1801), a work as handsome in its way as Vivaldi's *The Seasons* (1725). The theme has been treated as a cycle of four works by many artists, most notably Cosimo Tura, Brueghel the Elder, Watteau, Arcimboldo, Flaxman, Delacroix, and Millet. In our own time, Grant Wood, Paul Cadmus, Christopher Fry (his cycle of four plays), and Pavel Tchelitchew (all four seasons arch across *Cache-Cache*).

In Burchfield we see a complete abandonment of classical allusion, as well as a suppression of all narrative such as Thoreau employs in the structure of *Walden*. We have instead a return to a wholly archaic, raw re-seeing. To return to the deepest roots of a tradition is a Modernist tactic to which modern American art has been particularly sensitive. William Carlos Williams and Gertrude Stein attempted to avoid all traditional molds in preference for a primal freshness.

Let us admit that Botticelli's *Primavera* and Burchfield's *Oncoming Spring* (1954)

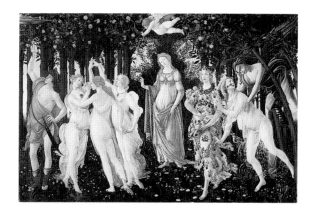

Sandro Botticelli, PRIMAVERA, c. 1478
Panel, 80 x 124 inches
Uffizi Gallery, Florence

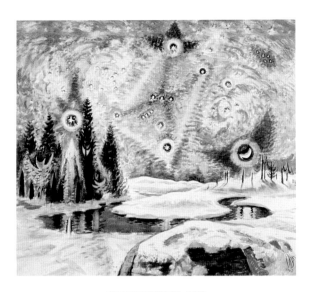

ORION IN WINTER, 1962
Watercolor on paper, 48 x 54 inches
Thyssen-Bornemisza Museum, Madrid, Spain
Photograph courtesy of Art Resource, NY

are the same subject in distant styles. Botticelli's painting is readable on various levels of symbolism and allegory. Its beautiful figures, trees, and flowers serve the sensual delight of our eyes, philosophy, mythology, and religion. It is a masque at the Medici court, an Ovidian poem, inextricably woven into the tapestry of Florentine history.

Burchfield's painting is, by contrast, naked snow, bare trees, and light flaring off icy wind-whipped branches. He has attempted the delineation of wind, or are those parabolas light? Comic-strip graphs of motion? The trees are trembling. The sun has melted patches into the snow. A great force is driving from the left into bulwarks of snow. Subatomic particles had left their traces in physicists' cloud chambers when this painting was done. Light under the scrutiny of Niels Bohr and Einstein had become a fifth element.

Seasons slide into each other. In many paintings Burchfield studies the moment when summer is just beginning to decay into autumn, or, as here, when strong winds and a subtle change in light bring the first breath of spring into a winter wasteland. In *Gateway to September* (1946 – 1956) August cicadas drill the air as an aura of golden light explodes upward from a meadow.

The word *season* is agricultural; its ancestor in Latin means *seedtime.* The word *hour* comes from the more usual Latin for season; the *horae commutationes,* "the changing seasons," was the Roman year. It was their sense that time stands for awhile; a season is a *statio*, a standing (this is the word that becomes season). Seasons divide into days, days into hours, hours into minutes, *momenti temporis.* Ancient time was fluid and unclocked. Our time is measured by atomic pulses, in nanoseconds. It is tense with anxiety, bedeviled by a fanatic precision.

28

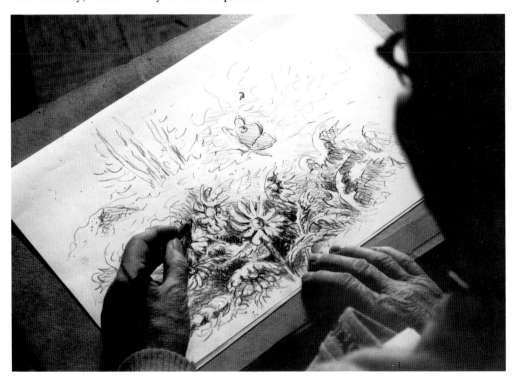

CHARLES BURCHFIELD SKETCHING IN HIS STUDIO, undated
Photograph by William Doran, Burchfield Photograph Archive
Burchfield Art Center, Buffalo, NY

There are many paintings of Burchfield's in which the duration of the tone of light, of the *feeling* of a moment, is a matter of seconds. *Yellow Afterglow* has an exact date (July 31, 1916); a meteorologist could give us the hour. The warm pinks and yellows show that the sun is on the horizon beyond the trees, which, along with the telephone poles, have become silhouettes. The old clapboard house, much weathered, is time's marker in this study of a quiet summer evening.

My own taste for Burchfield began with such paintings: sunflowers in a backyard, hydrangeas soaked with sunlight around an old house, small-town streets with trees in all kinds of weather. My next perception was that his imagination and versatility, like Hokusai's or Paul Klee's, was endless. He was not trapped, like Benton or O'Keeffe, in a trademark style. His mind, to use a poetic analogy, was somewhere between Wordsworth and Blake; that is, between a contemplative exultation and a visionary adoration of nature. The backyard sunflowers in hot afternoon light would become in time the magnificent *Summer Solstice* (1961 – 1966), which seems to me to be Burchfield's ultimate achievement. It is what all works of great art must be, a communication of a state of mind. It must also be native to its medium, however much it can claim kinship with others; in this watercolor, with the intensest melodies of Sibelius, with other pastoral visionaries like Turner, Samuel Palmer, and Monet. The tree is a geyser of green and gold. It is a Romantic painting in that the artist has imposed his own ecstatic feeling onto an innocent tree in a meadow (of no interest to a cow, except as shade). It is not a Mediterranean painting; it is Northern, it is Druid, Scandinavian, mystical. And yet it is thoroughly American—Thoreau could have come close to finding words for a description of it. It could illustrate Tolkien's golden tree brought back to the Shire from Rivendell. It is a poem by Emily Dickinson. It is music by Elgar. No other American painter could have done it. Genius is always unique.

Burchfield went far beyond the poetic daring of *Summer Solstice* into hieroglyphics of stars and moths and zigzag light, into fantasies that include all four seasons in one picture, into near-abstractions of what seem to be apocalypses. His work is so rich that its periods can supply museums with large collections in which he might seem to be only a painter of Ohio small towns, or of mid-American industry, or of woods and forests in all weathers, or of domestic tranquility, or of Creation as the essence of all earthly beauty.

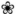

1
YELLOW AFTERGLOW, July 31, 1916
Watercolor with pencil on paper
20 x 14 inches
Collection of the Burchfield Art Center, Buffalo, New York
Gift of Tony Sisti, 1979:29

Quotes accompanying the color plates are taken from *Charles Burchfield's Journals: The Poetry of Place*, edited by J. Benjamin Townsend, Albany: State University of New York Press, 1993, pages 18, 118, 229, 274, 304, 308, 312, 323, 324, 372, 373, 412, 416, 445, 451, 465, 510, 518, 523, 539, 542, 544, 574, 599.

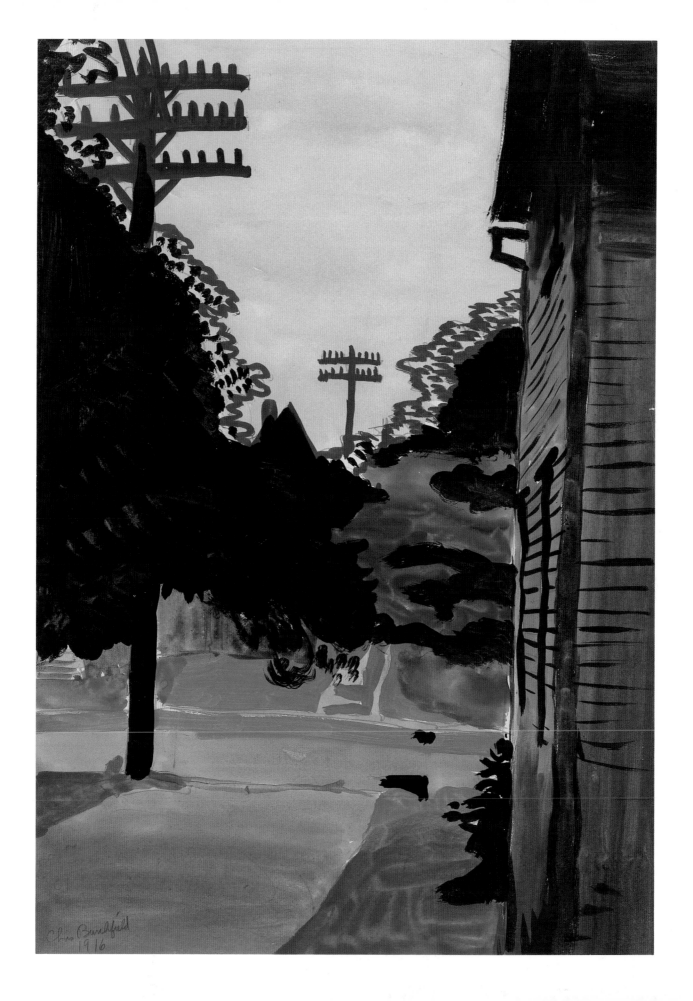

2
AUTUMNAL WIND AND RAIN, 1915
Watercolor and pencil on paper
14 x 20 inches
Collection of Mr. Harry D. Yates
Courtesy of the Burchfield Art Center Archives, Buffalo, New York

Who can sound the depths of the wind? Whence comes this life-creating
blast of icy air. Yesterday — so quiet & sultry — today so wild & cool. When
the wind is blowing we must expand & swell else we be blown away. Trees
grow tall and with stiffened trunk[s] let their limbs relax to be waved and
tossed at the will of the wind.

Salem, July 28, 1914

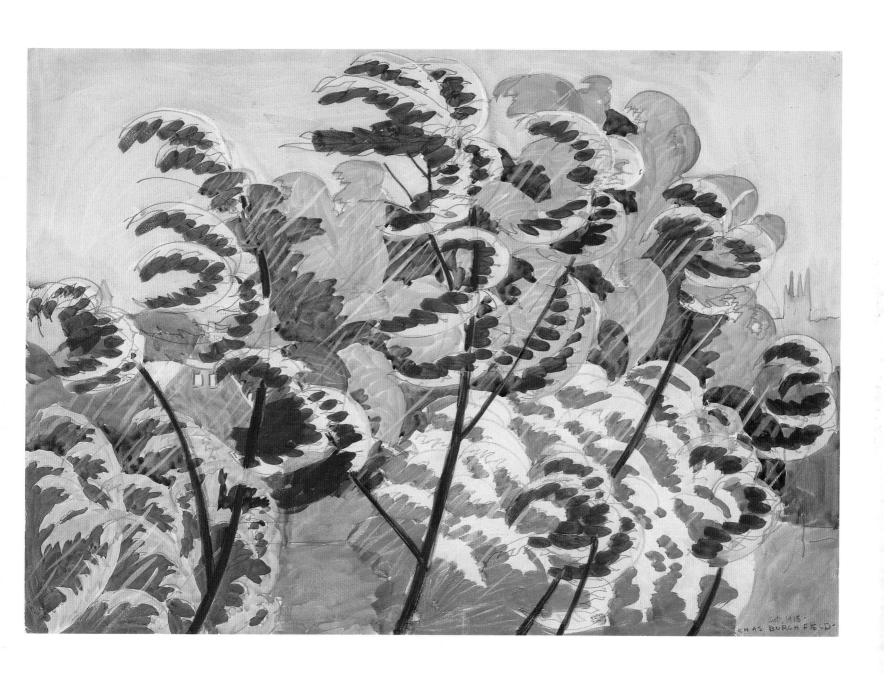

3
GHOST PLANTS, 1916
Watercolor and pencil on paper
20 x 14 inches
Honolulu Academy of Arts, Hawaii
Purchase, 1983

A dream: . . .

Every flower in the garden was white—first in order came huge
sunflowers—the leaves and stalks pale gray green, the flowers with pale
greenish white discs, surrounded by large, curling, luxuriant rays or petals,
a waxy snowwhite. Next in order come gigantic white carnations—they
had just been watered, and the cool dampness resulting was filled with their
powerful scent—Next came some white gladiolas, which Shakespeare said
were his special pride—"Crescent Moon Gladiolas" he called them, and
on closer examination, I saw the reason for his name—The over-large
flowers, with curling petals, when partly open, twisted in such a way that
they formed an irregular, but unmistakable crescent. Altho I did not
actually turn and see it, I felt that if I did turn and look, I could have seen
the crescent moon itself low in the southwest sky. An atmosphere of peace,
and remoteness, hovered over the scene, and I thought how far away and
trivial the war seemed.

With the smell of mignonette in my nostrils, I awoke.

Gardenville, December 22, 1942

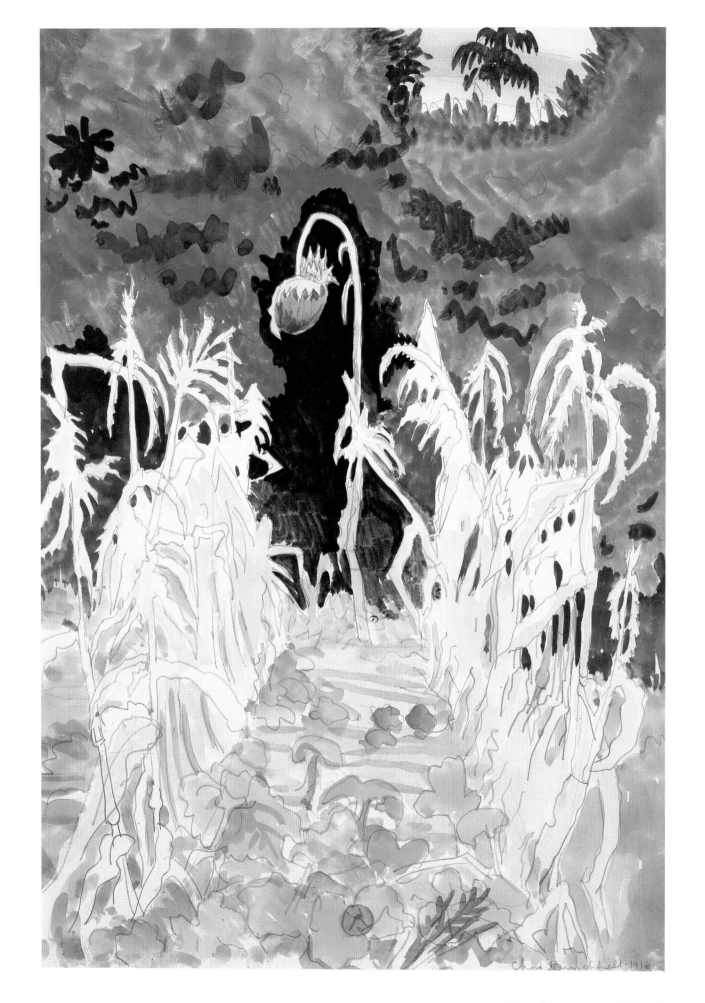

4
MOON THROUGH YOUNG SUNFLOWERS, 1916
Gouache, graphite and watercolor on paper
19⅞ x 14 inches
The Carnegie Museum of Art, Pittsburgh, PA
Gift of Mr. and Mrs. James H. Beal, 67.3.5

I have not been viewing nature with a composing eye—I have not imagined
rainfall on sunflowers; or sunflowers dying coming up against the moon.
What a host of field compositions!

Salem, September 9, 1916

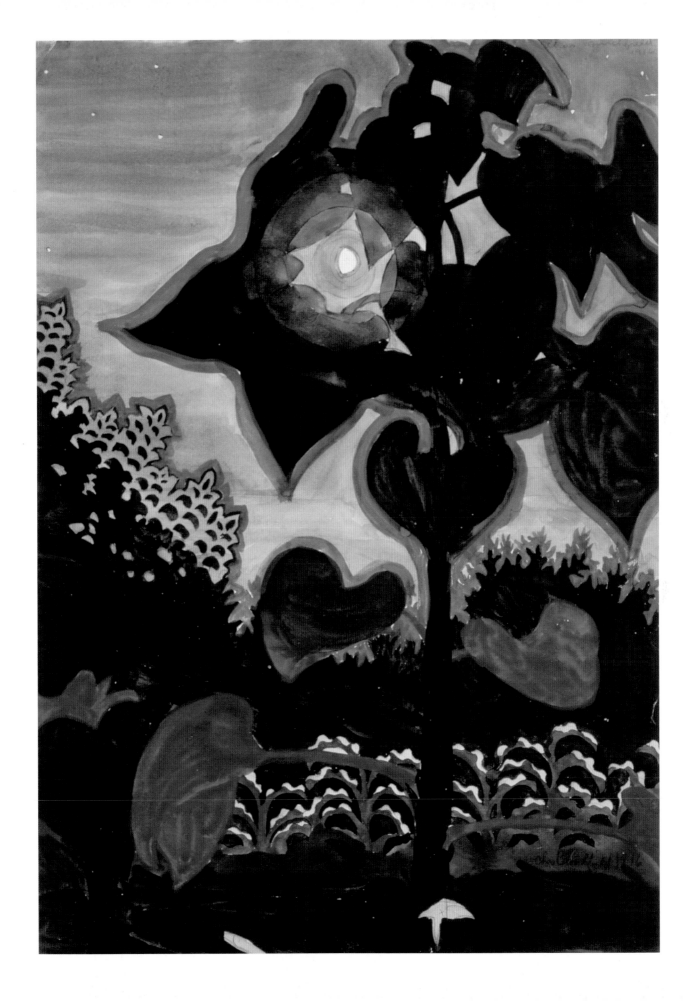

5
NOONTIDE IN LATE MAY, 1917
Watercolor and gouache on paper
21⅝ x 17½ inches
Whitney Museum of American Art, New York
Purchase 31.408

It is May! The buckeye trees are almost fully out, and hang loosely with great masses of vivid emerald foliage—there is nothing to equal this brilliant color of green—the sun shines on it in a subdued silvery highlight, & the partly cloudy sky beyond is composed of pale violets—a cool breeze comes out of the sunlit south—Maple trees are speckled with twin leaves that form horizontal dashes across their branches—The shadows under porches suddenly become intensified & full of poetry—It is the kind of a day that should have its lawnmower going.

Buffalo, May 11, 1922

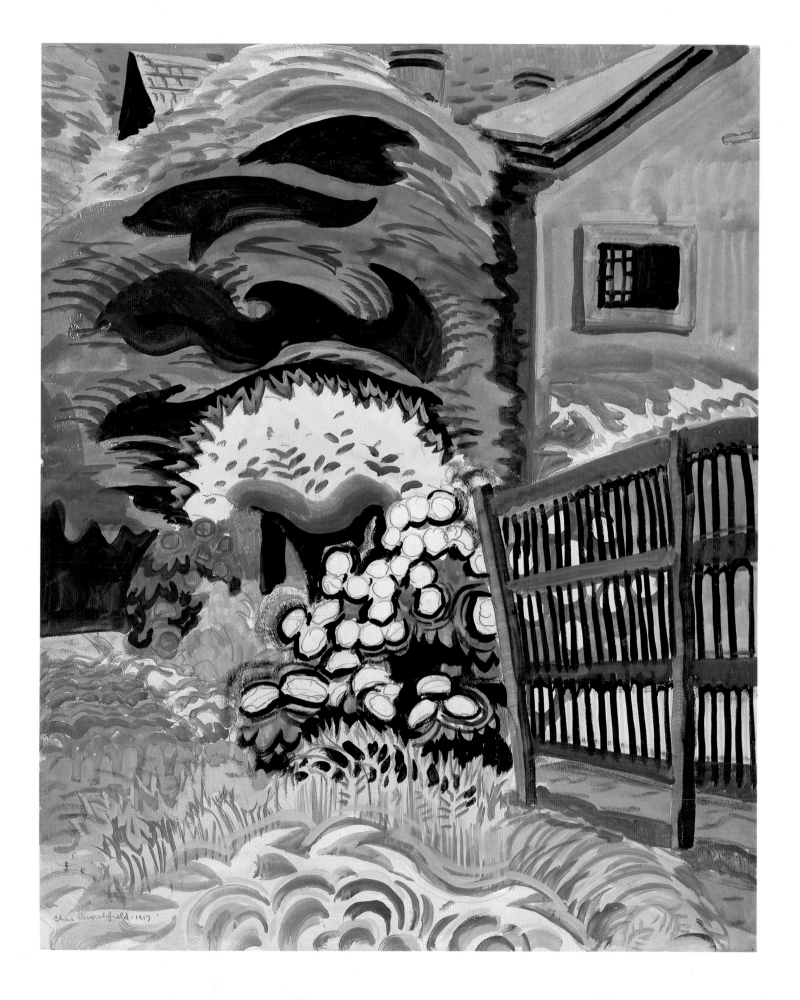

6
HILL TOP AT HIGH NOON, 1925
Oil on cardboard
31 x 22 inches
Pennsylvania Academy of the Fine Arts, Philadelphia
John Lambert Fund

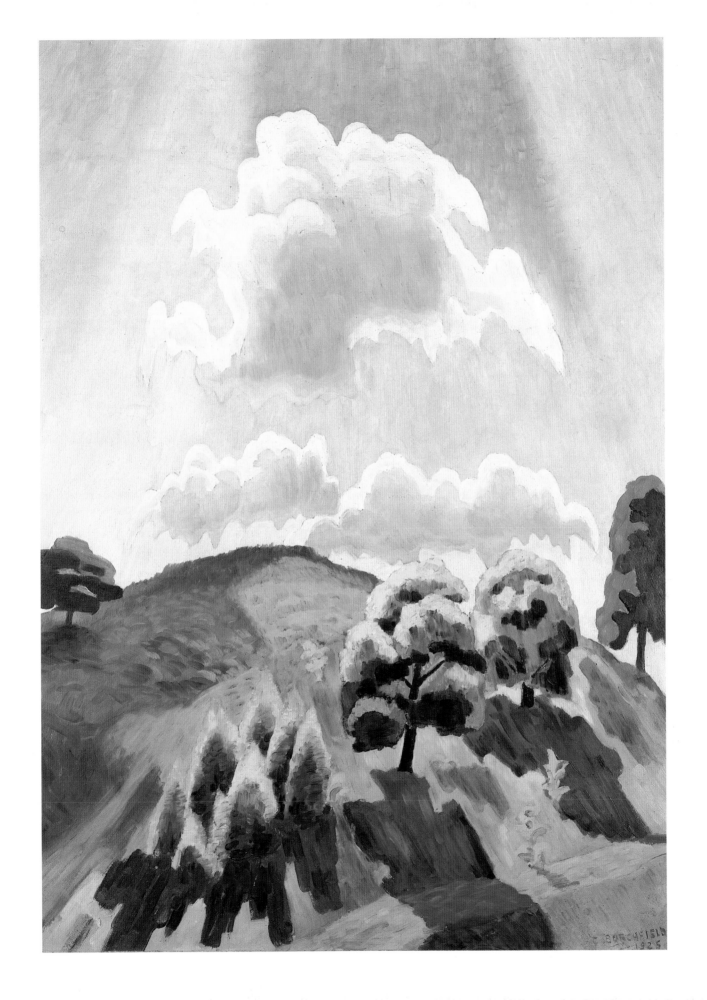

7
HOUSE BY A RAILROAD, 1927
Watercolor and crayon
15⅞ x 20¾ inches
Munson-Williams-Proctor Institute, Museum of Art, Utica, New York
Edward W. Root Bequest

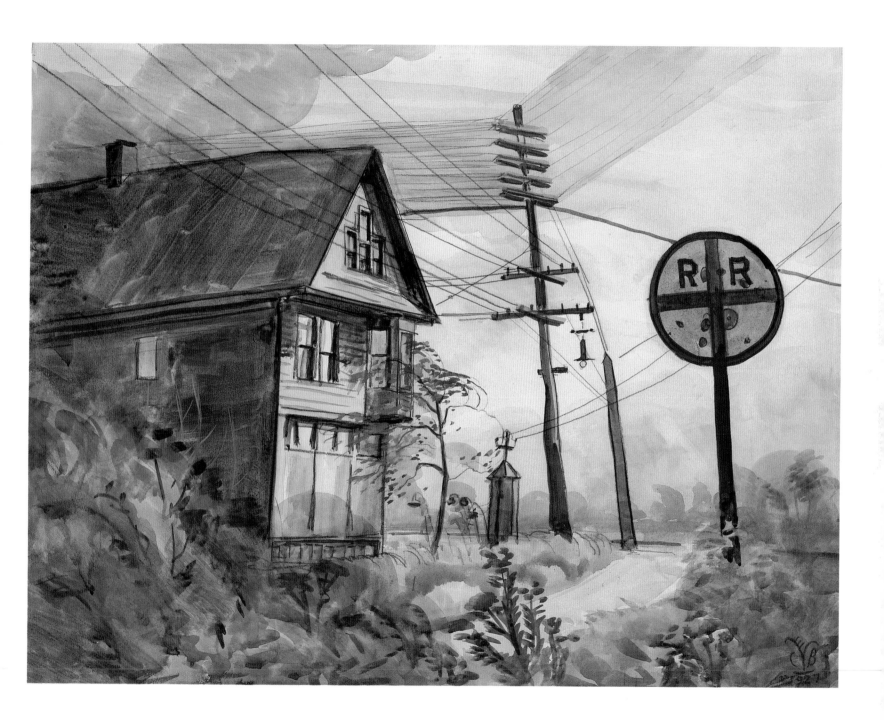

8
RAINY NIGHT, 1929-30
Watercolor over pencil on paper
30 x 42 inches
San Diego Museum of Art
Gift of Anne R. and Amy Putnam

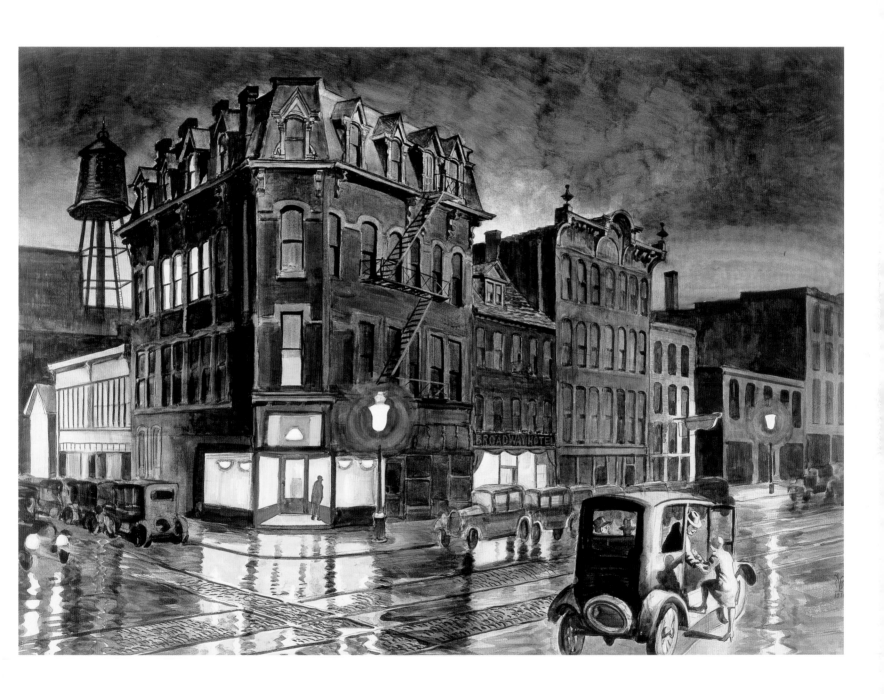

9
ICE GLARE, 1933
Watercolor on paper
30¾ x 24¾ inches
Whitney Museum of American Art, New York
Purchase 33.64

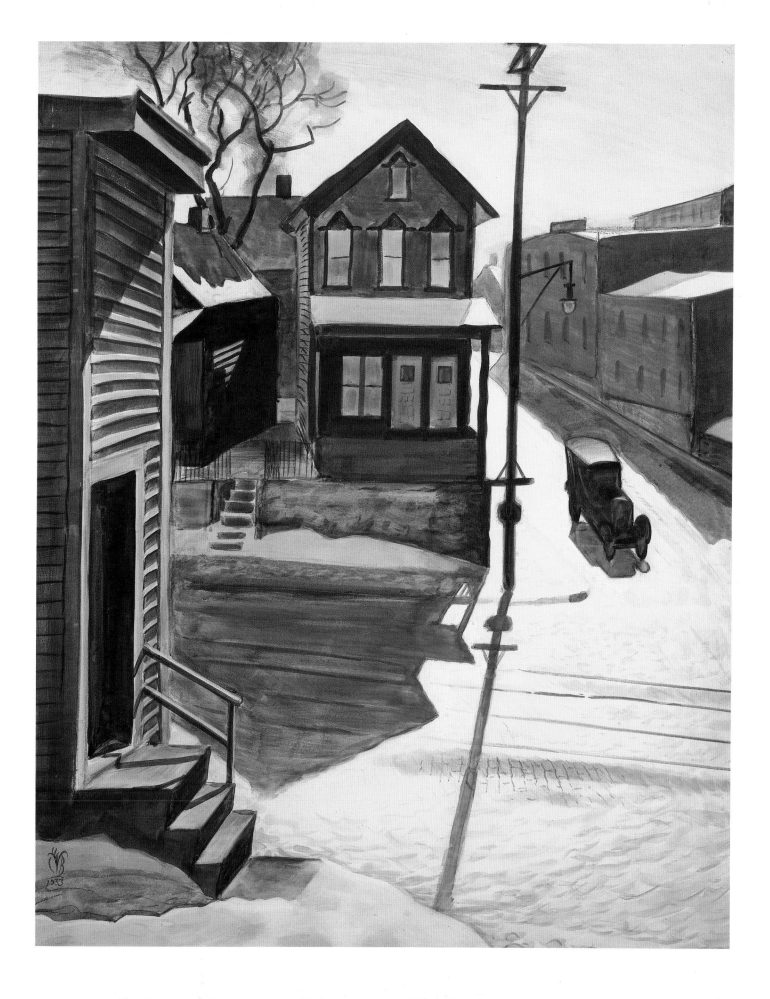

10
END OF THE DAY, 1938
Watercolor on paper
28 x 48 inches
Pennsylvania Academy of the Fine Arts, Philadelphia
Joseph E. Temple Fund

I took the train from Pittsburgh to Steubenville, with a certain misgiving in my mind—I was going to visit again my Ohio river country, that I knew and loved in 1920 & 1921—but would I find it changed, or I so changed that it would have lost its charm for me? That neither has happened fills me with a great intoxicating joy. A bitterly cold day—at Steubenville, I seek the hilly street where in 1921 I made a pencil study of some old houses—I find them practically unchanged in eleven years—perhaps a little better—After making another study I take a streetcar for E. Liverpool—The vast grim primitive country between Steubenville and Toronto is overwhelming—here is untouched virgin material—long low shanties & brick kilns huddling at the foot of vast grim bald-topped hills—

Gardenville, January 31, 1932

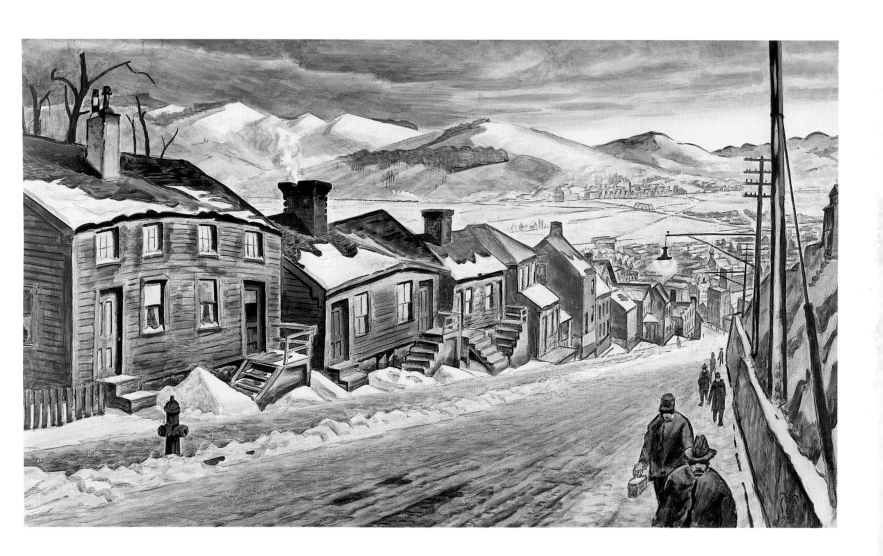

11
MARCH SUNLIGHT, 1932
Watercolor on paper
18 x 27 inches
Courtesy of Kennedy Galleries, Inc., New York

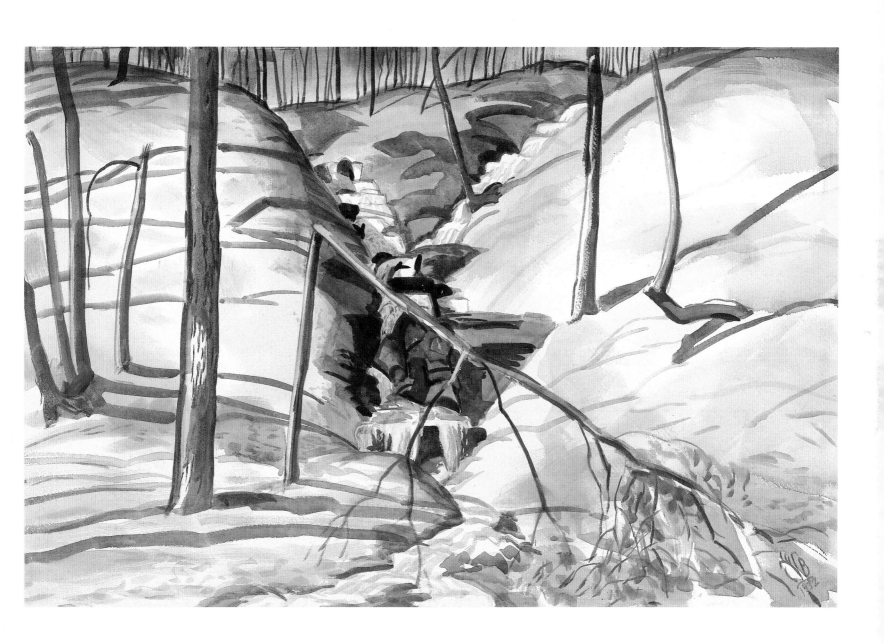

12
JUNE WIND, 1937
Watercolor on buff wove paper mounted on chipboard
23 x 27⅞ inches
Worcester Art Museum, Worcester, Massachusetts
Gift from Chapin and Mary Alexander Riley Collection, 1986.45

If all musical sounds were to be forever silenced—orchestras, bands, human voices, birds & insects—and I were allowed to retain one sound to cheer me, I would ask that the wind might play in the tree-tops.
The wind! Motion is life. All is dead that stands still.

Salem, August 17, 1914

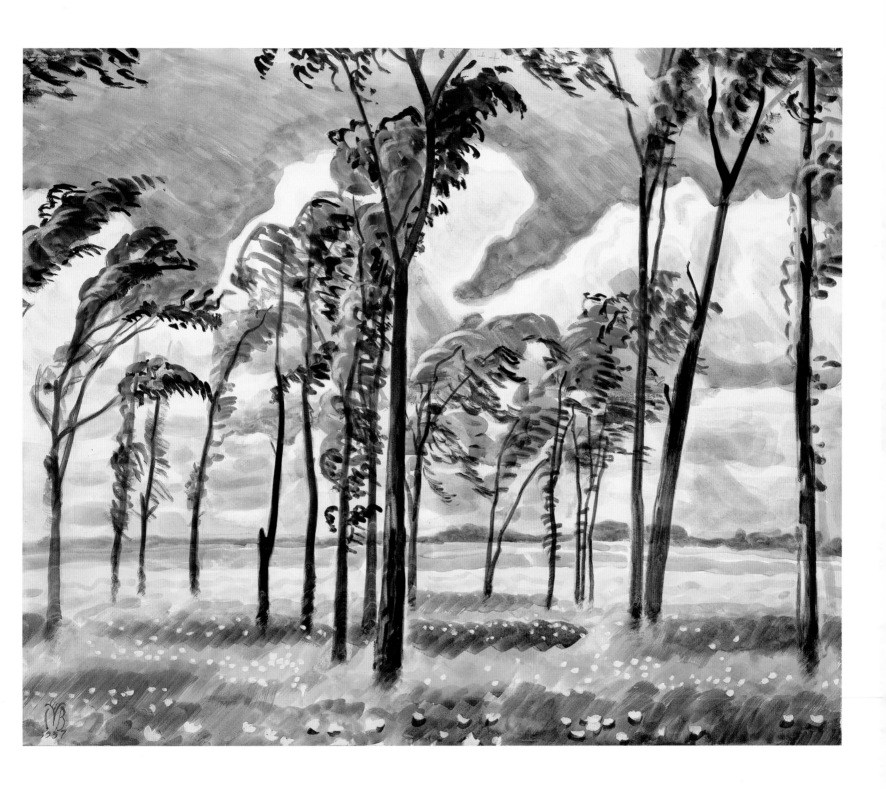

13
THE THREE TREES, 1931-46
Watercolor on paper
36 x 60 inches
Salem Public Library, Salem, Ohio

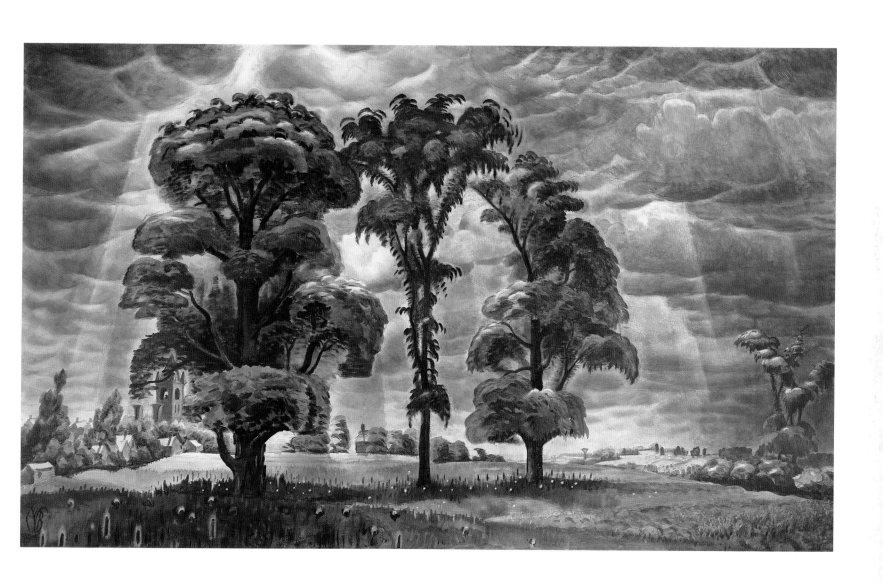

14
THE COMING OF SPRING, 1917-43
Watercolor on paper, 34 x 48 inches
The Metropolitan Museum of Art, New York
George A. Hearn Fund, 1943

So completely did the personality of the stream enter into my consciousness, that at night when I lay down to sleep, my pillow seemed to be full of sound, and closing my eyes, I saw endless frothy cataracts, and little waterfalls, that came from an infinity above, and vanished downwards, thru a succession of ravines that likewise extended to another, and lower infinity. In retrospection [*sic*], the banks became steeper, the downward progressions more abrupt, and dangerous; as I lay in bed, growing drowsier, my whole being seemed submerged in this noisy headlong torrent, until I too was rushing downwards, a part of it.

Gardenville, March 31, 1943

15
AUTUMNAL FANTASY, 1916-44
Watercolor on paper
37 x 52½ inches
Private collection
Courtesy of the Burchfield Art Center Archives, Buffalo, New York

I long for the woods. — The woods! — I often wonder what I am, naturalist or artist, for the pursuit of one hinders the other — I seem always to be deciding which it shall be — Of course it must be an artist, for it [*i.e.*, I] must live, but I am hoping for a day when I can give myself entirely up to Nature.

Cleveland, October 8, 1913

16
LAVENDER AND OLD LACE, 1939-47
Watercolor on paper, 37 x 50 inches
New Britain Museum of American Art, Connecticut
Charles F. Smith Fund
Photograph: E. Irving Blomstrann

All day on the "Lavender & Old Lace"—I am changing the whole mood; from a gray day effect, I am making it late twilight; I am adding elements to the house & barn observed on other gothic houses; and added two huge elms back of the house, etc. In a word, I have abandoned the idea of a specific house & locale, and [am] making it an expression of all I feel about gothic houses.

For most of the morning I fumbled, unable to strike the proper mood; then, completely subconsciously I made a few impatient stroke[s] about the middle gable, and suddenly had the key to the mood. From then the work went more smoothly.

Gardenville, May 31, 1947

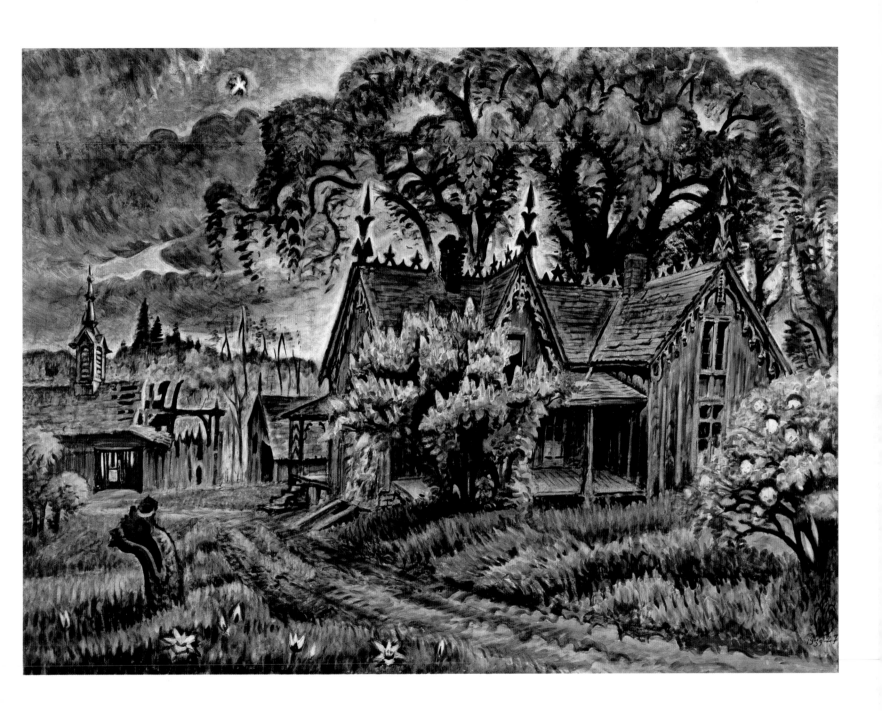

17
THE SPHINX AND THE MILKY WAY, 1946
Watercolor 52⅝ x 44¾ inches
Munson-Williams-Proctor Institute
Museum of Art, Utica, New York

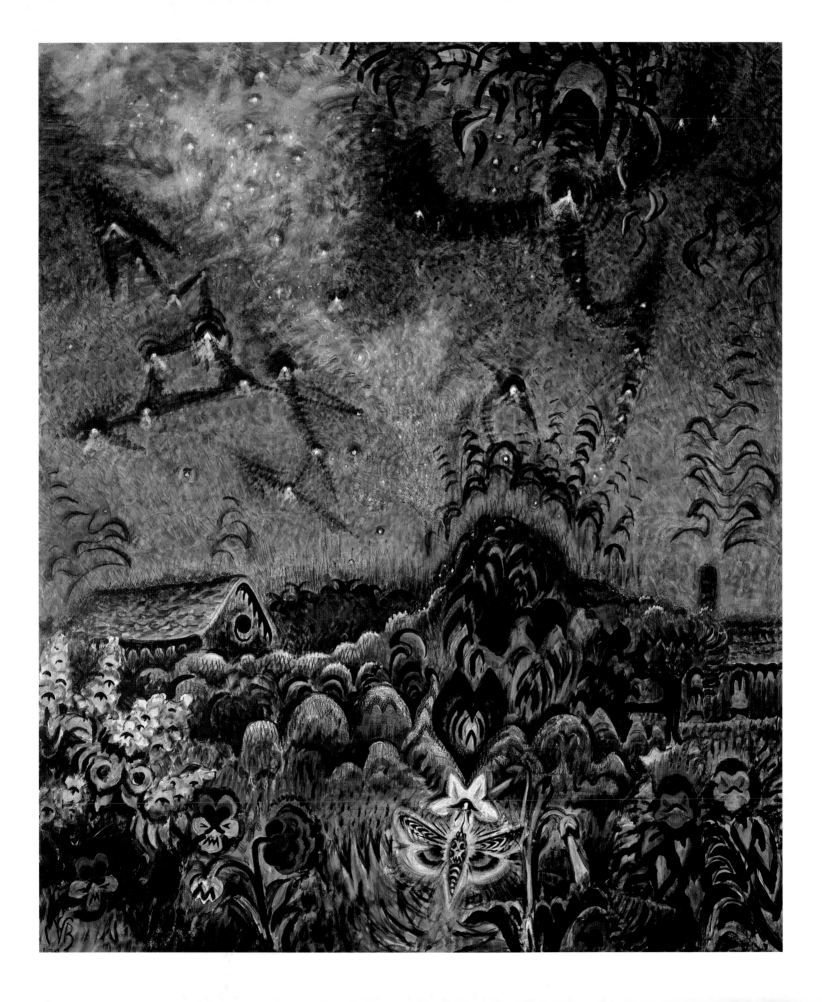

18
HUSH BEFORE THE STORM, 1947
Watercolor on paper
40 x 30 inches
Wichita Art Museum, Wichita, Kansas
The Roland P. Murdock Collection

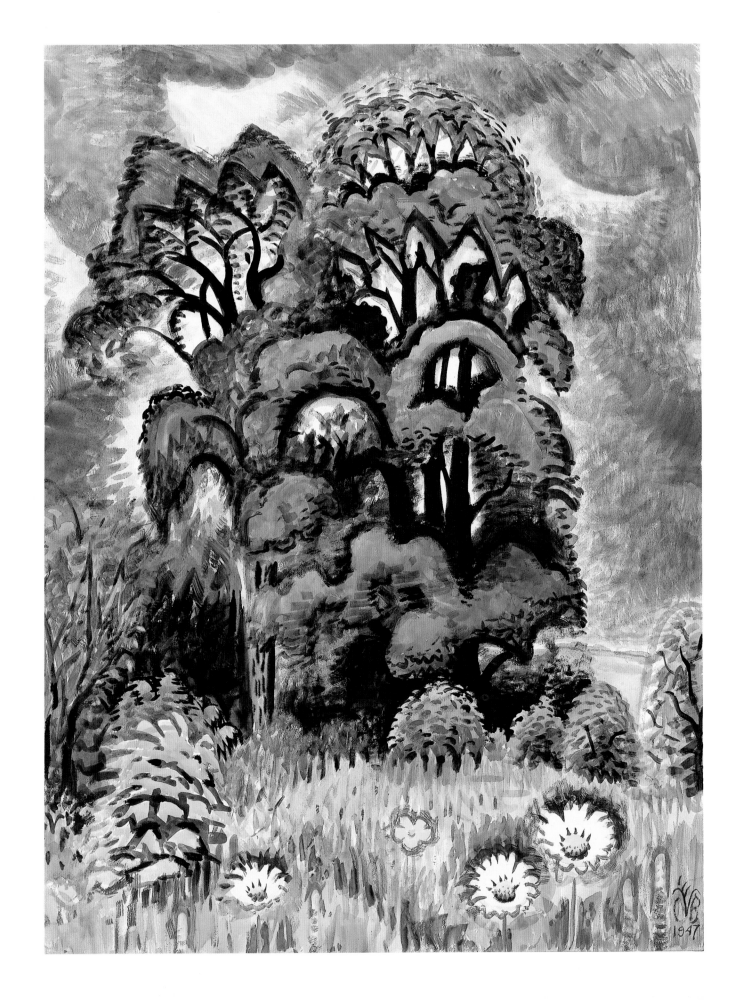

19
CLOVER FIELD IN JUNE, 1947
Watercolor on paper, pasted on heavy board
40 x 29 inches
The Metropolitan Museum of Art, New York
George A. Hearn Fund, 1948

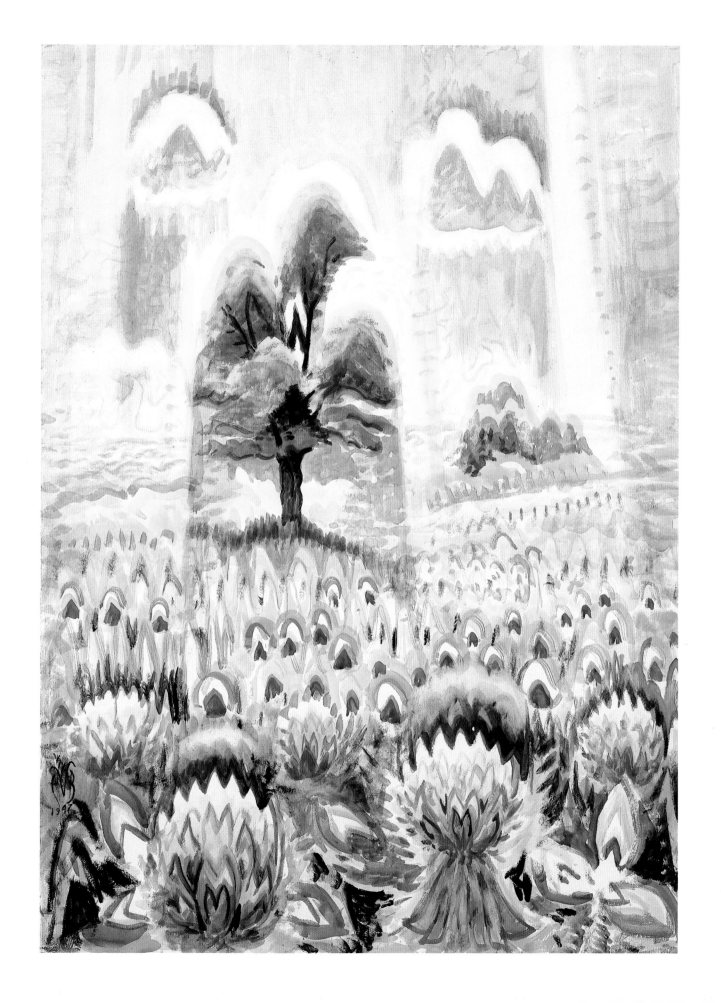

20
GOLDENROD IN DECEMBER, 1948
Watercolor on illustration board
26 x 40 inches
Whitney Museum of American Art, New York
Gift of Flora Whitney Miller in honor of John I. H. Baur 74.62

There is nothing in nature that will ever fail to interest me.

Salem, March 25, 1911

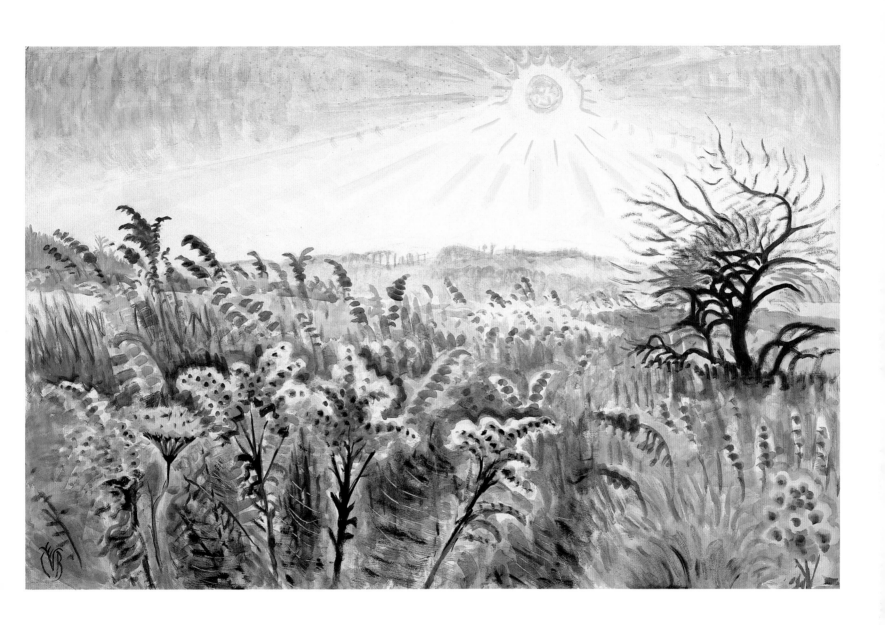

21
SUMMER AFTERNOON, 1948
Watercolor on paper
Williams College Museum of Art
Gift of Mrs. Lawrence H. Bloedel, 83.4.1

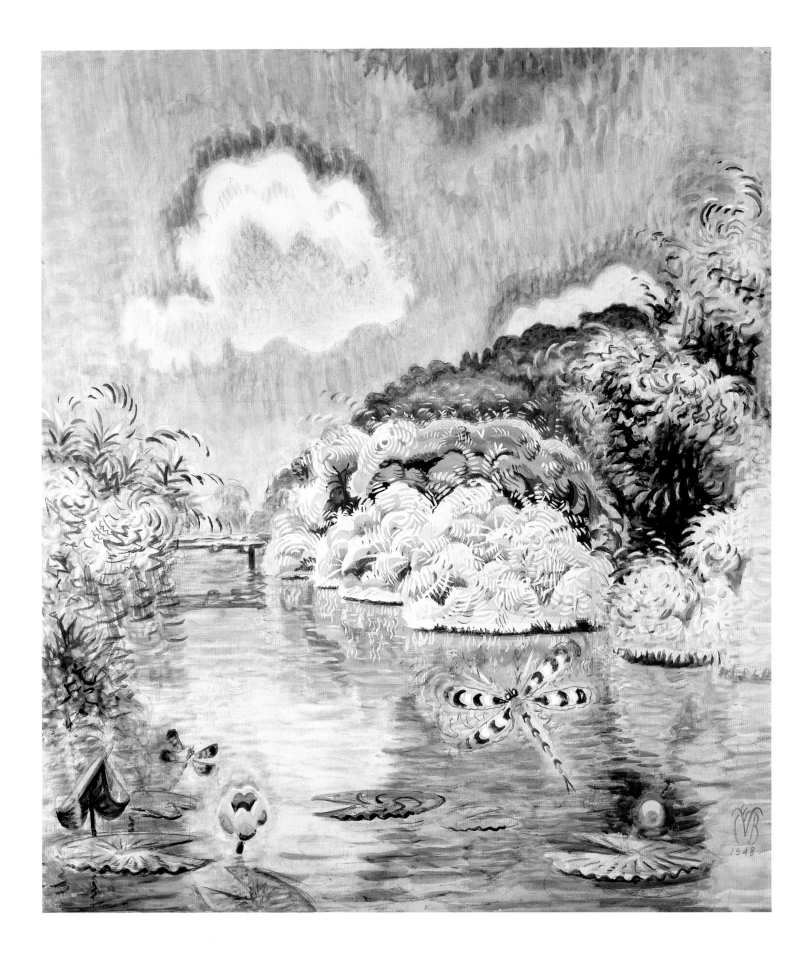

22
THE HEMLOCK GROVE, 1948
Watercolor on paper
40 x 26 inches
Courtesy of Sid Deutsch Gallery, New York

It is more "winter" (negation—void—absence of life) without snow than with—In January on bright snowy days, there is a vital quickening in the air, and sunlight, that already smacks of March fire; but now with no frost even in the soggy ground—no wind—an impenetrable blanket of cloud hanging low over the earth as if to smother it—dead weeds and grass uncrushed by snow—trees wet and black—a dense milky haze pervading the air, accentuating the distances between objects, between planes, there is an unutterable melancholy, a complete negation that is overwhelming—it seems as if at last the earth, and all things in it stood still and would never "move" again—never quicken again but moulder with a long, drawn out decay and reversion to earthly material—

I stand spellbound, unable myself to move for the power and wonder of it.

Gardenville, January 23, 1932

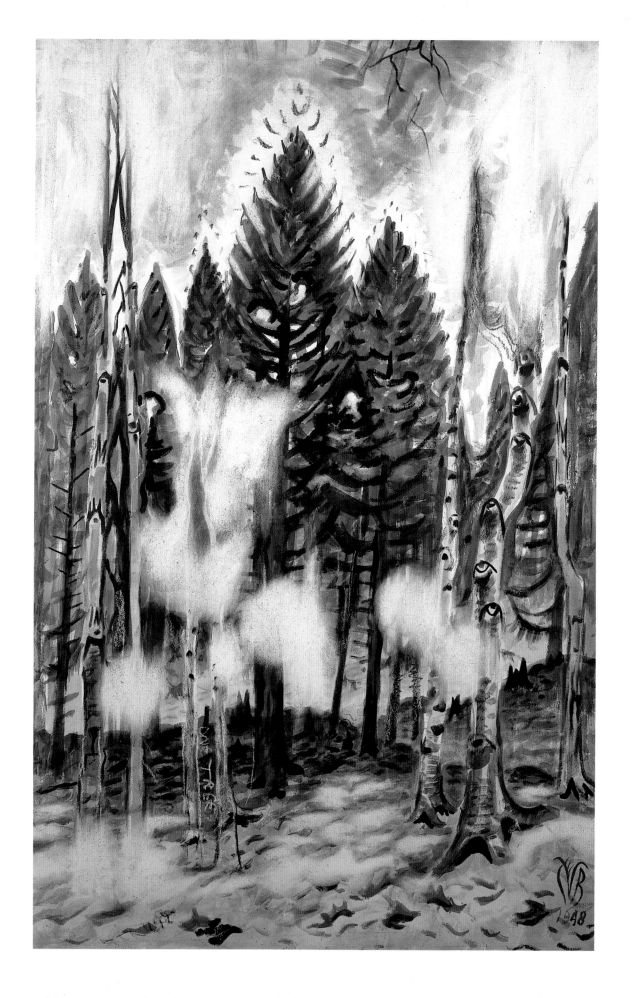

23
STILL LIFE IN WINTER, 1951
Watercolor and pencil on paper
29⅞ x 40 inches
National Museum of American Art, Washington, DC
Photograph courtesy of Art Resource, New York

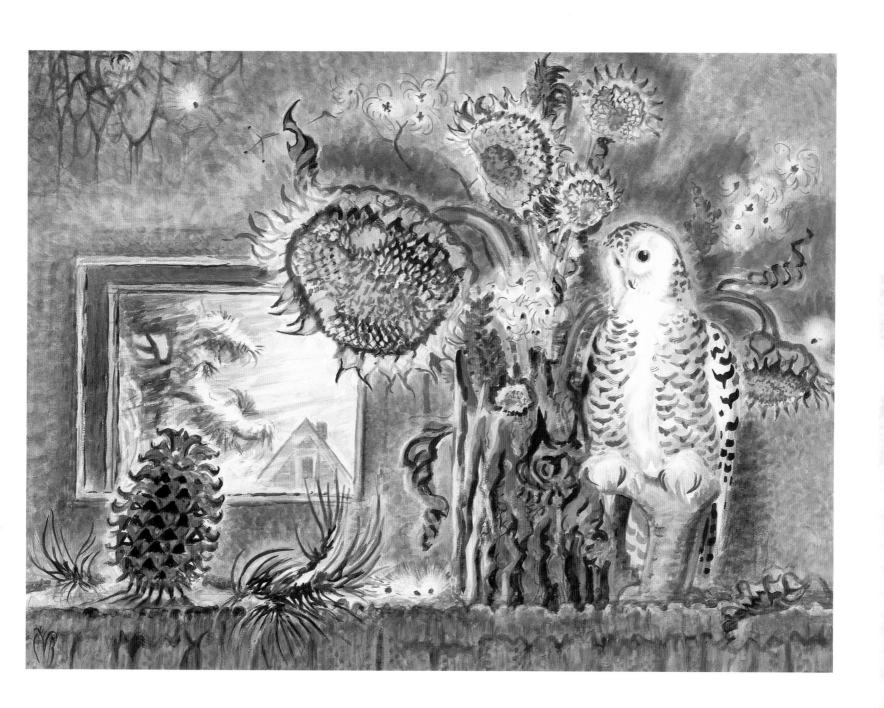

24
WIND-BLOWN ASTERS, 1951
Watercolor
30 x 40 inches
Collection of the Burchfield Art Center, Buffalo, New York
Anonymous Gift, 1968:1

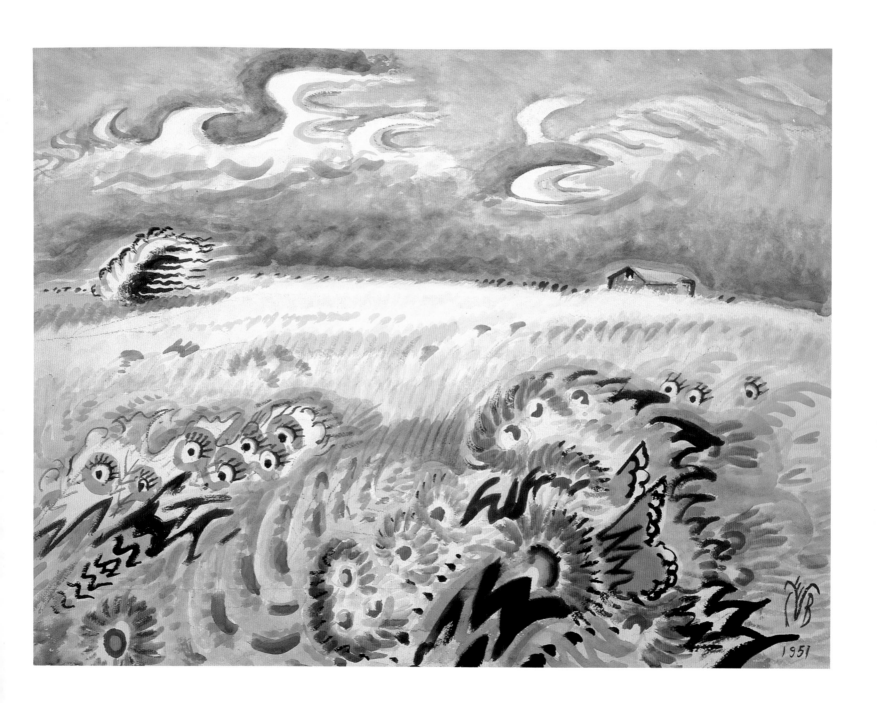

25
ONCOMING SPRING, 1954
Watercolor on paper, 30 x 40 inches
Collection of the Burchfield Art Center, Buffalo, New York
Purchased in part with support from the Western New York Foundation and
the Olmsted Family in memory of Harold L. Olmsted, 1990:3

This is a Spring morning. Spring is merely a state of the mind. The year goes around devoid of seasons for some, while others must consult the almanac. Rain is in the air. The snow is slowly settling into blue ice. The sky is a queer mixture—here dappled, there long stre[t]ches of misty expanses, a delightful pattern of yellow & blue. . . . Out of the southwest comes the wind in puffs and lulls; the trees wave back and forth violently against the sky and are next motionless and instantly the wind is heard roaring far to one side. Such a wind can only belong to Spring. There is a sense of blowing far far away as it rushes into the sunlit east and the desire is to go with it.

Cleveland, February 11, 1915

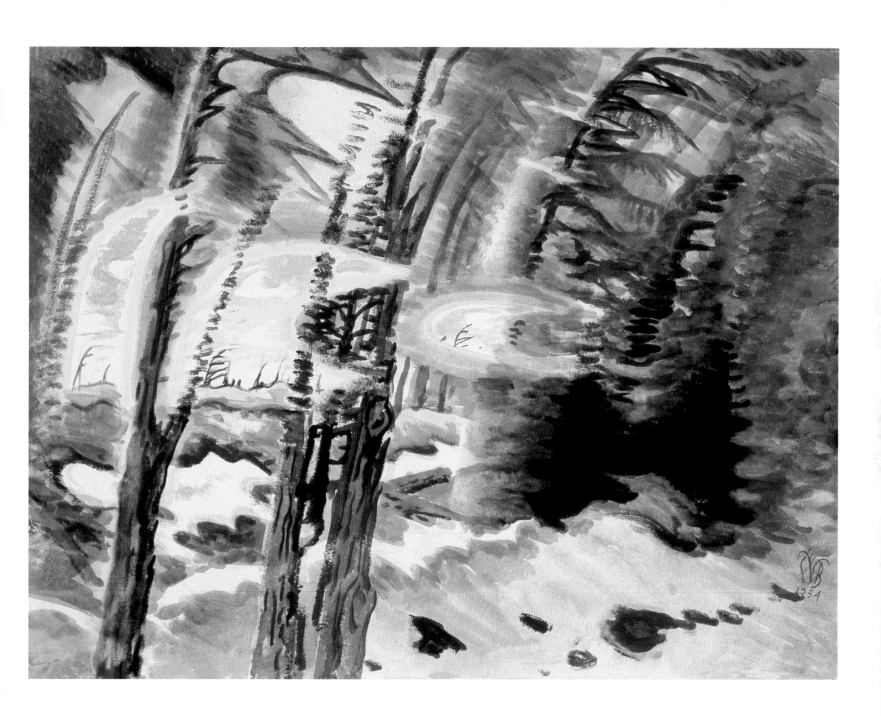

26
NIGHT OF THE EQUINOX, 1917-55
Watercolor, brush and ink, gouache and charcoal on paper
40⅛ x 52⅛ inches
National Museum of American Art, Washington, DC
Photograph courtesy of Art Resource, New York

The great difficulty of my whole career as a painter, is that what I love most (i.e. weather, change of seasons) not only holds little of interest for most people, but in many of its phases, is downright disagreeable, and not even to be mentioned! I love the approach of winter, the retreat of winter, the change from snow to rain & vice-versa; the decay of vegetation; and the resurgence of plant-life in the spring—

Gardenville, October 29, 1952

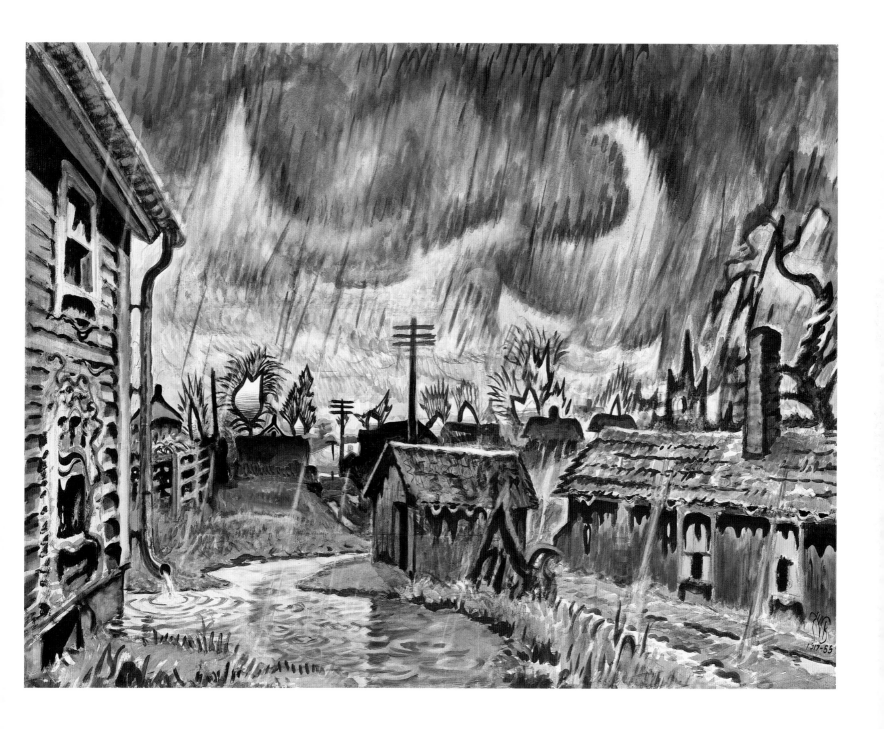

27
FANTASY OF HEAT, 1952-58
Watercolor on paper
40 x 30 inches
Private collection
Courtesy of the Burchfield Art Center Archives, Buffalo, New York

The long drought and heat wave coming so early, makes strange contrasts. The fields have no rankness, there is no hay, and lawns are turning yellow, but most of the trees have yet that startling emerald quality that goes with early June—the air is stifling, dry, the sunlight brassy and glaring, suggestive of mid-August, but as I walk along, now comes the rank odor of honey locust, or the rich odor of lily-of-the-valley, and also the unidentifiable mixture of countless pollens, all seeming anachronistic.

It seems wonderful to think of rain falling, to see cool cloudy skies, to be able to hear thunder—such things seem fabulous now. Perhaps it was some terrible prehistoric drought that gave birth to religion or prayer.

Gardenville, June 5, 1934

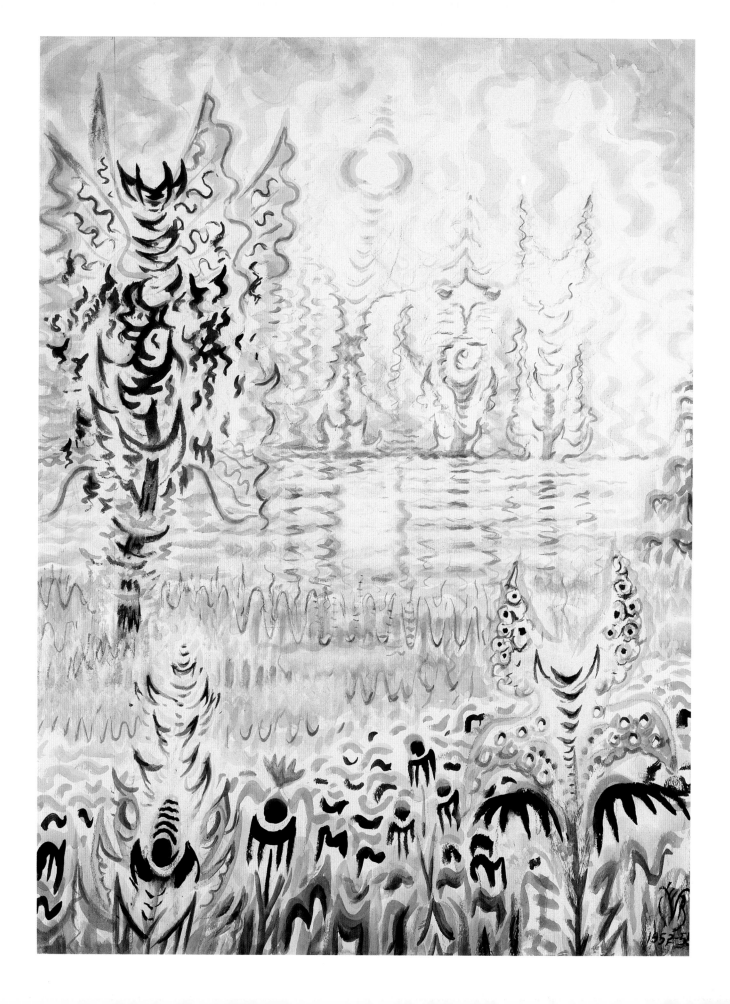

28
GATEWAY TO SEPTEMBER, 1946-56
Watercolor on paper
42½ x 56 inches
Hunter Museum of Art, Chattanooga, Tennessee
Gift of the Benwood Foundation

Hazy sun-spoked mornings; white glowing house-roofs; dk [dark] western sky;

noon—z-ing of katydids, high shrill pin-point cricket chorus; darting of yellow & white butterflies—dark blue grey north sky, whitish sepulchral sunlight over things, dry leaves rattle in wind, a cicada; dying sun-flowers;

afternoon sunlight turns whiter, cold like moonlight, the katydids subside, leaving the pinpoint cricket song; searing grass; sad sunlight on windows—

night—the saffron yellow dusk dims to a black star-studded sky, the night chorus commences—

Salem, September 14, 1917

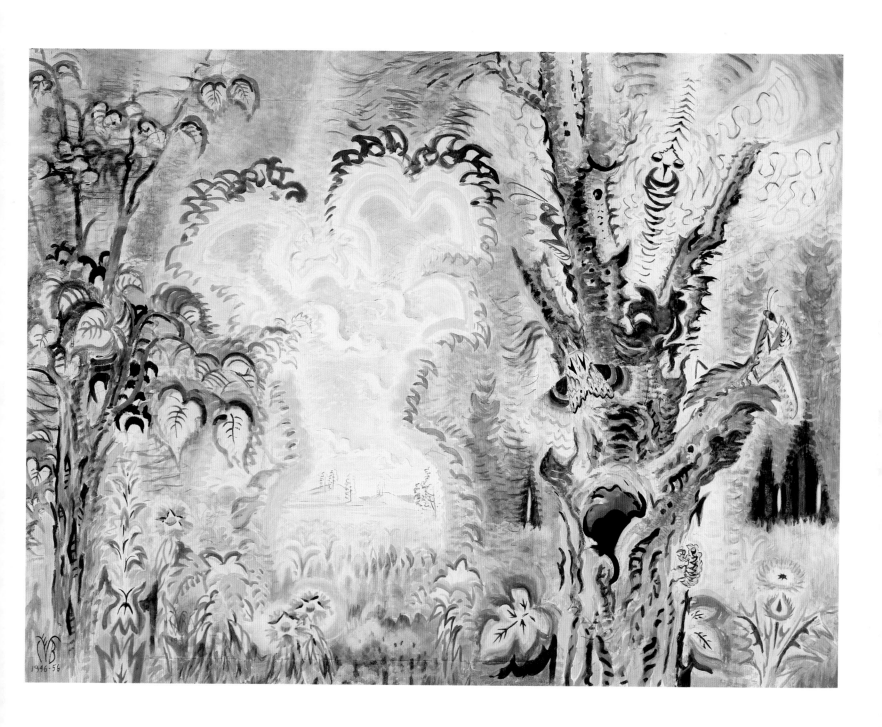

29
PURPLE VETCH AND BUTTERCUPS, 1959
Watercolor over charcoal on white wove paper
39¾ x 29¾ inches
Pennsylvania Academy of the Fine Arts, Philadelphia
John Lambert Fund

This is my beauty—all the beauty I wish for: the love of this nature around my home. They talk of Italian skies. I envy not the Italian. Nor do they envy me. I find no sympathetic beauty in the sky I have not lived under. The Elysian fields are not at the ends of the earth—they are here at my feet.

September 25, 1914

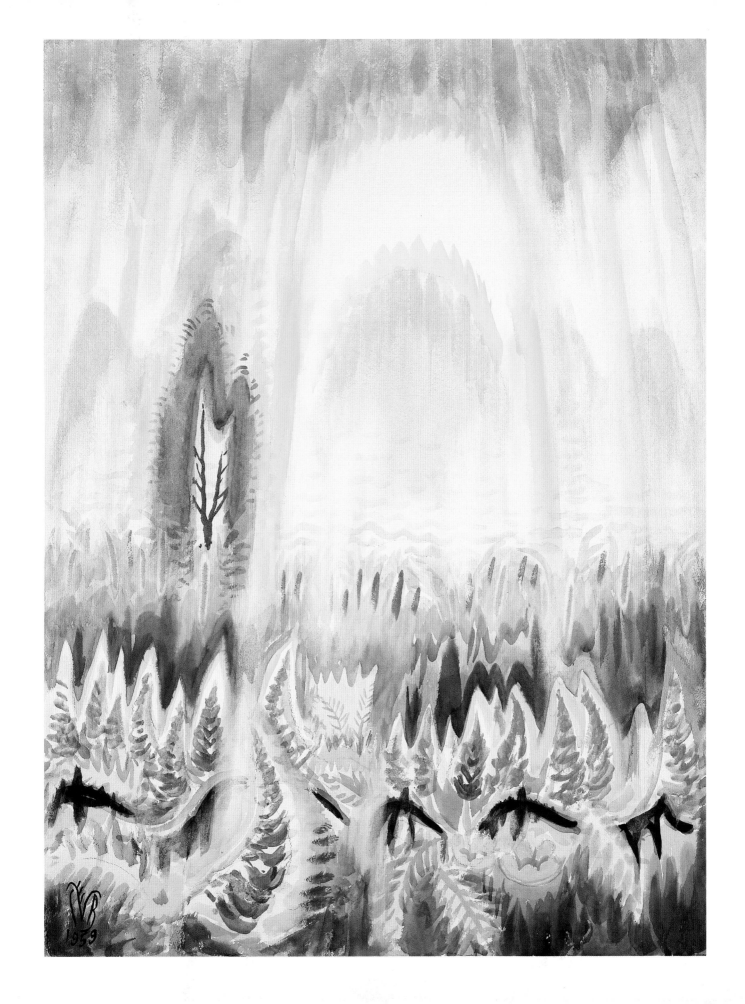

30
AUTUMN LEAVES AT PLAY, 1950-59
Watercolor on paper, 30 x 40 inches
Private collection
Courtesy of the Burchfield Art Center Archives, Buffalo, New York

When we came into the drive this morning and I got out of the car, I was struck with the beauty of the dead leave[s] by our neighbor's garage — the sort of beauty that is absolute. The soft tones of brown, lavender, yellow brown & reddish brown, with sharp accents of green grass, were very satisfying. Later I watched whirling leaves in sunlight — and it was revealed to me suddenly that it was not leaves & sunlight, but beautiful abstract colors in motion, in ordered movement. The whole world from that tiny event was all at once re-created.

Gardenville, November 3, 1936

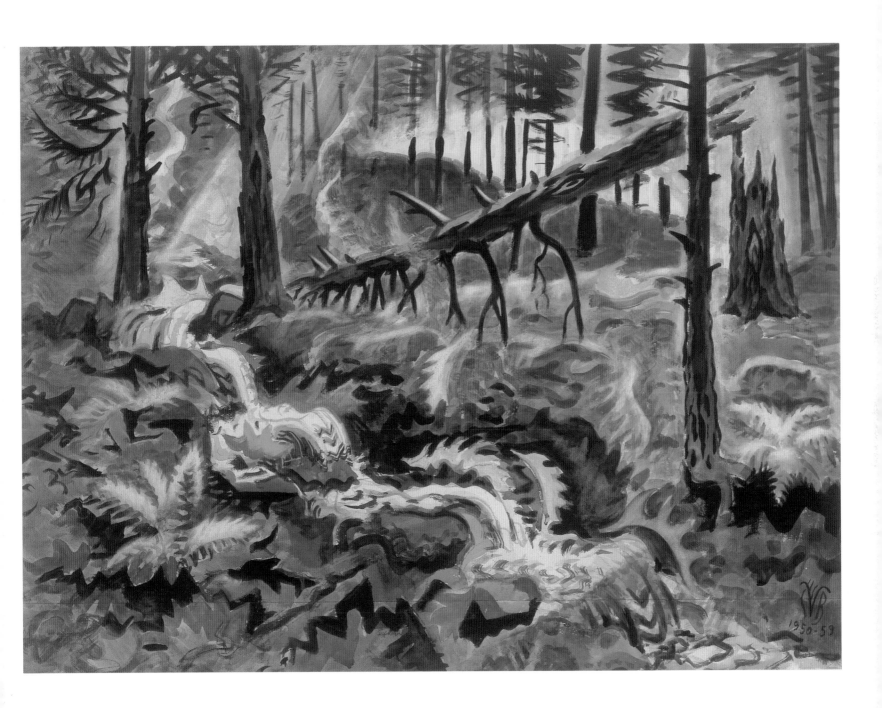

31
ORION IN DECEMBER, 1959
Watercolor and pencil on paper
39⅞ x 32⅞ inches
National Museum of American Art, Washington, DC
Photograph courtesy of Art Resource, New York

The other night I lay awake, tortured by a multitude of thoughts; outside the sky was blanketed with soft strangely luminous clouds, in which now and then appeared ragged holes thru which glowed the deep indigo sky — black star-studded caves that moved majestically toward the south. In one I saw two brilliant stars, and wondered what they were; the hole advanced revealing suddenly three stars in a row, and I realized I was looking at Orion. A feeling of peace and comfort came over me at the sight of this beautiful group, like some Being saying "All is well" —

Gardenville, November 17, 1933

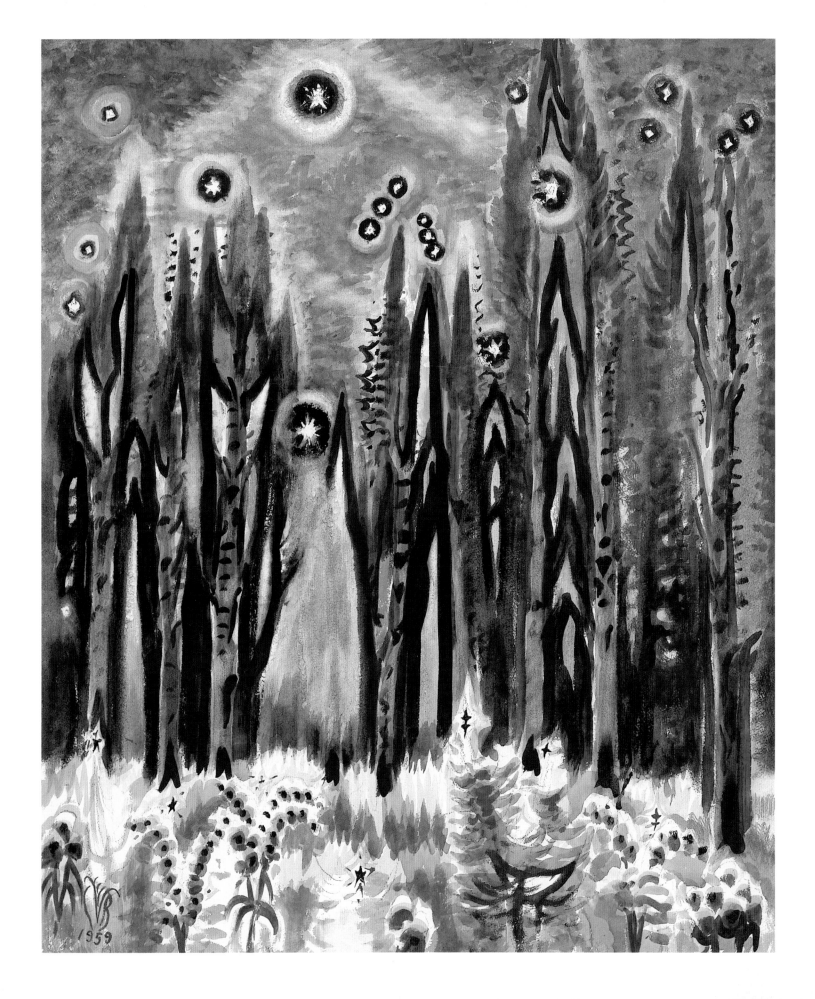

32
MOONLIGHT IN JUNE, 1961
Watercolor on paper, 45 x 33 inches
Mead Art Museum, Amherst College, Amherst, Massachusetts
Bequest of Mary Louise Whittemore, in memory
of Eugene B. Whittemore, Class of 1924

The other day going over my early summer 1915 notes—remembering a note on a moon reflected in the Little Beaver below Covered Bridge. I finally found it. It evoked memories of June twilights and nights along the Little Beaver; and of thick white mists lying low in the chilly meadows; of myriad fireflies; and ghostly arrowhead flowers—

Today I painted a moonlight fantasy based on these memories, with enormous elm-shaped phantoms rising up toward the moon, white-crowned—a "never-never land" that fills me with happiness.

June 10, 1961

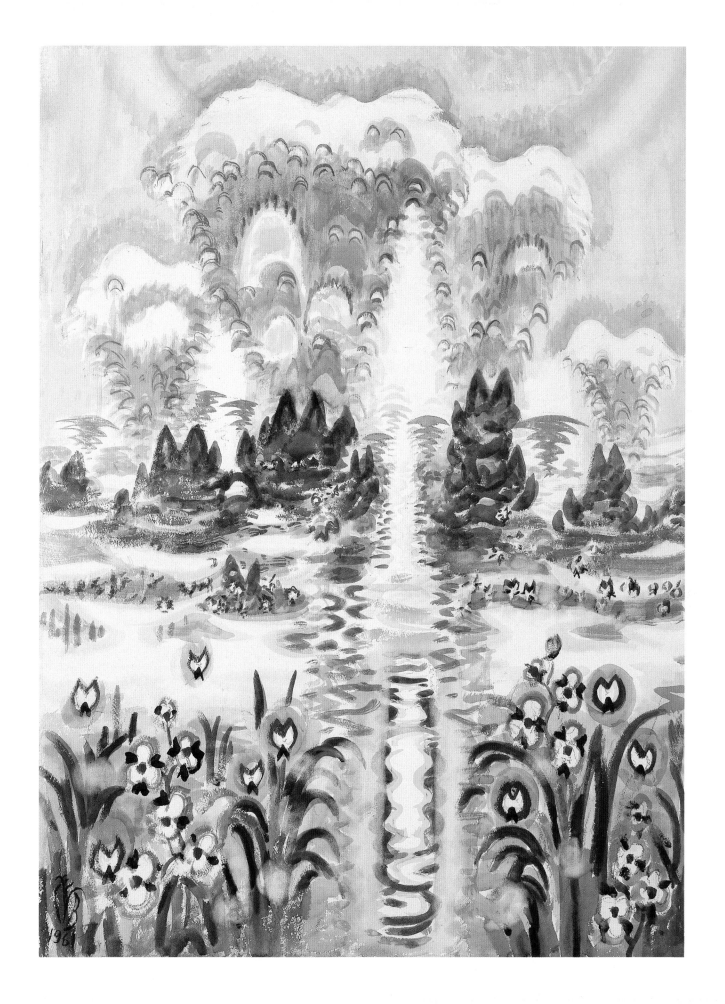

33
GOLDEN DREAM, 1959
Watercolor on paper
31¾ x 38 inches
Promised 50th Anniversary Gift of a private collector
to the Whitney Museum of American Art, New York, P.11.80

Countless butterflies sipping honey—the "butterfly dance" come true.
Great tiger swallowtails (I counted them, never less than eight or more than
14), Monarchs, on[e] black swallowtail, & countless silver-spots, bees,
and one hummingbird hawk-moth. Every so often the silverspots and more
rarely the others, would all fly up and chase each other furiously in small
circles. The swallow-tails kept to themselves, usually at one end of the
patch. Once I saw five on one plant. The odor of the flowers was too
sweet to be borne long.

Gardenville, July 14, 1949

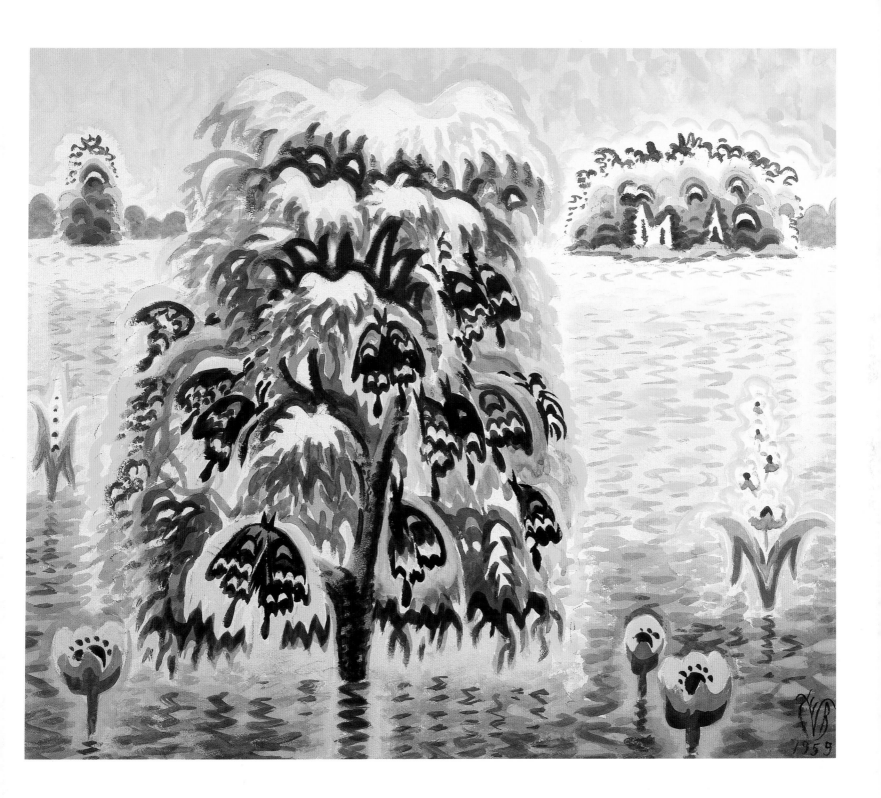

34
WILD SWEET PEAS IN A SUMMER RAIN, 1965
Watercolor
Private collection
Photograph courtesy of Art Resource, New York

At noon the sky clears off but almost immediately a storm appears in the northwest. We are on the outskirts of it; on this account we have a rare combination of sunlight and rain. The rain—straight falling big drops—comes in "regiments"—there is music in the roaring sound of the rain approaching, ever growing louder like a wind penetrating a woods, until finally the air is streaked with great snowy drops; and then that sudden cessation of sound as it passes on; it is like the coming & passing shadows on a windy half-cloudy day.

At the height of such a shower, the sun, at the meridian, came out—what a miracle. It was like some masterpiece of music when there is a general softness of tone and all at once every instrument blares forth in an ecstasy of sound. Such was the sunlight shattering the rain—only far more wonderful. The falling drops caught the sunlight, sparkled brilliantly & carrying it to earth broke it into diamond dust; wet roofs caught and sent it shattering to the glistening tree-leaves where it hung momentarily, until jarred loose by the wind it came back thru the glossy elastic air, and so it flashed back and forth till the air was a sparkle of light.

Salem, August 21, 1914

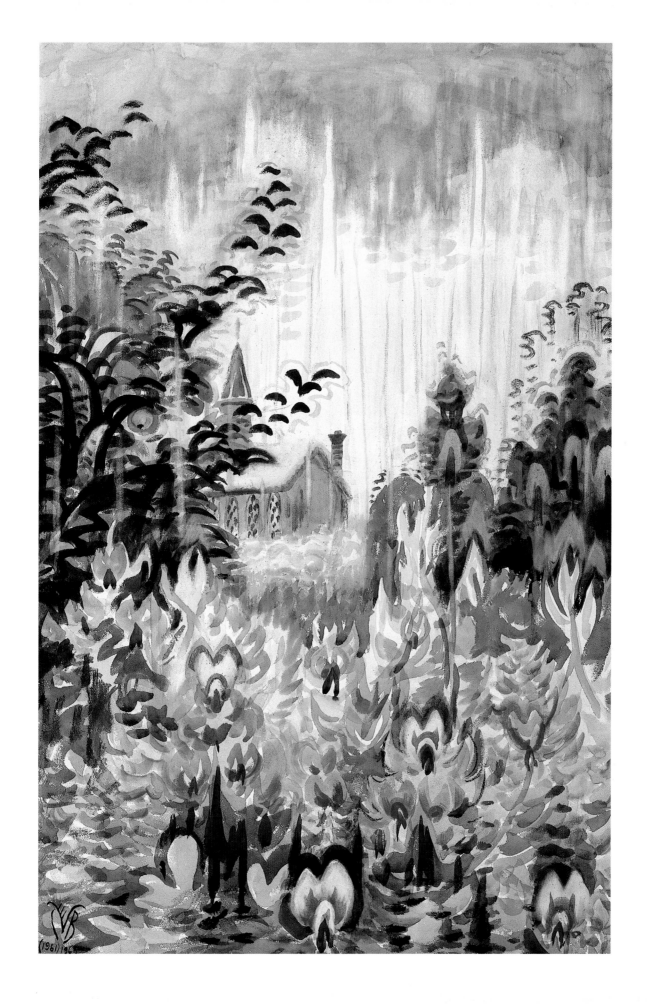

35
SUMMER SOLSTICE, 1961-66
Watercolor on paper
19¼ x 27 inches
Courtesy of Kennedy Galleries, Inc., New York

All day on "Summer Solstice" bringing it to a stage where I can begin to judge it a[s] a whole—The foreground, which in so many pictures is a problem (i.e., it has to "be there," but not detract too much from the main theme), after all seemed to solve itself, more or less. Employing daisies and buttercups (as the most familiar or common of childhood flowers) I found that they could not have even the slightest dark accent, but must be swimming in a glare of sunlight from the zenith sun, and therefore all but obliterated.

"A tree is a temple; God surrounds the innocent child (or man) with His presence.

"From behind a dark overhanging cloud the sunlight falls to earth from the Zenith, like Golden rain."

July 10, 1964

A sense of forlorn desolation fills me on the "finishing" of Summer Solstice—the end of a quest of forty years or more—or is it the end? I must put it aside and turn to new, more difficult things—"Genesis" ("and the Spirit of God . . .") is yet to be started, and many others—the "Blue Dome of June" was but barely launched last year—But the loneliness of a finished work nevertheless eats at me.*

*While an artist is still working on a theme, it fills his whole mind, he lives in that world—but once he brings it to a conclusion, he must leave that world, and find another to dream in—it is not always easy.

July 12, 1964

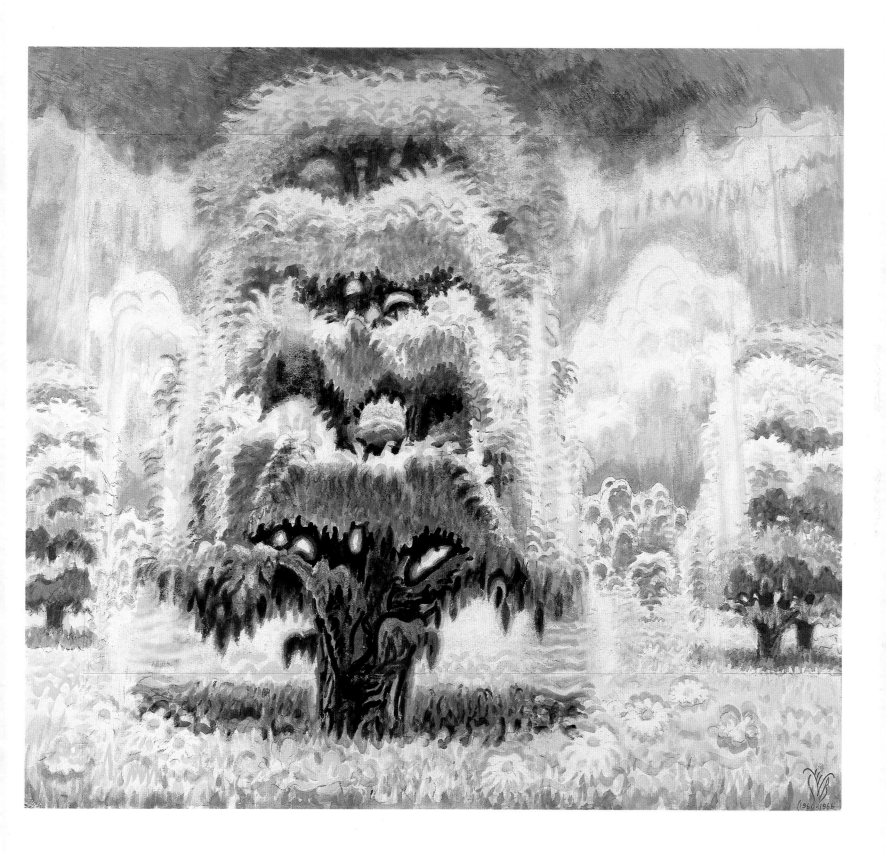

36
NORTH WIND IN MARCH, 1960-66
Watercolor on paper
47½ x 59½ inches
Ogunquit Museum of American Art Permanent Collection
Ogunquit, Maine

Very cold; some sun, and snow-flurries —

All day in the studio on "North Wind in March" (with some interruptions)...

In spite of this, the work went well on the picture — I established firmly the great black North motif in the sky, with wind clouds, the largest of which is spewing forth snow-flurries — I think I have established with the relation of the wind-blown red maples in bloom and the sky an inevitableness which every picture must have — that is, the assurance that absolutely no other arrangement could possibly be right....

This picture gives me great joy. How slowly the "secrets" of my art come to me — It seems to me I have been searching all my life for this motif of Black North combined with the wind-cloud and snow-flurry....

Gardenville, March 30, 1964

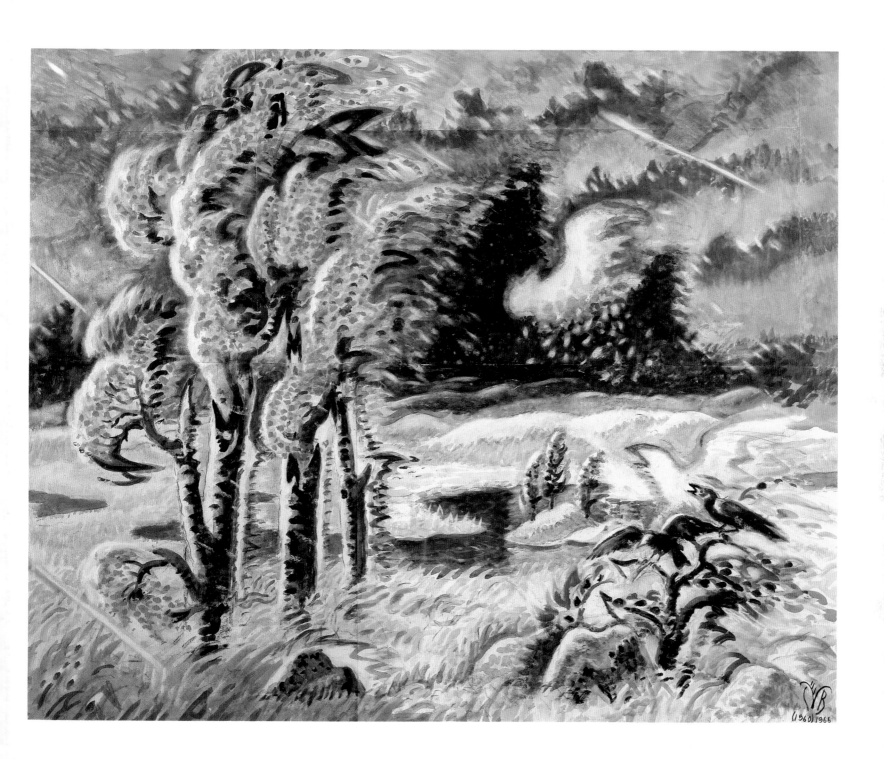

SELECTED BIBLIOGRAPHY

Baigell, Matthew. *Charles Burchfield*. New York: Watson-Guptill Publications, 1976.

Baur, John I. H. *The Inlander: Life and Work of Charles Burchfield, 1893 – 1967*. East Brunswick, New Jersey: Associated University Presses, Inc., and Cornwall Books, 1982.

Boswell, Peyton. *Modern American Painting*. New York: Dodd, Mead & Co., 1940.

Butler, David. "Extending the Golden Year: Charles Burchfield." *American Art Review,* Spring 1993.

Craven, Thomas. *A Treasury of Art Masterpieces*. New York: Simon and Schuster, 1939.

Hoopes, Donelson F. *American Watercolor Painting*. New York: Galahad Books (Watson-Guptill), 1977.

Licata, Elizabeth. "A Burning Vision." *Art & Antiques,* Summer 1993.

Munson-Williams-Proctor Institute, Museum of Art, *Charles Burchfield: Catalogue of Paintings in Public and Private Collections*. Introduction by Joseph S. Trovato. Utica, New York, 1970.

Townsend, J. Benjamin, ed. *Charles Burchfield's Journals: The Poetry of Place*. Albany: State University of New York Press, 1993.

Weekly, Nancy. *Charles E. Burchfield: The Sacred Woods*. Burchfield Art Center, Buffalo State College, State University of New York Press, 1993.

Wootten, Richard. "Paint the Town: Charles Burchfield in Salem, Ohio." *American Art Review*, Spring 1993.